IMAGES
of America

ORCHARD PARK

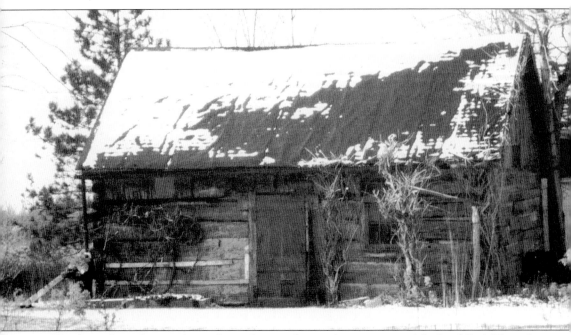

This hewn log cabin was located on a farm in the northwest corner of Orchard Park Township between Michael Road and Southwestern Boulevard. It was probably built by German settlers, who preferred to hew their logs to a square rather than use them in their original rounded condition. Pictured in 1980, the cabin has since been demolished. (Courtesy of John Conlin, *Heritage* magazine.)

On the cover: This *c.* 1905 photograph was taken in front of the Anthony & Ormsby Drug Store on the southwest corner of West Quaker and South Buffalo Roads. Perhaps the men are discussing the benefit of horses over those newfangled horseless carriages or that upstart Harry Yates from Buffalo, or maybe they are just watching the properly attired, long-skirted young women go by. From left to right are William Smith (1850–?), Frank Murphy (1859–1930), and Ed Hodson (*c.* 1854–?). The building still stands today and is the home of Frame 'n Save.

IMAGES
of America
ORCHARD PARK

Suzanne S. Kulp and Joseph F. Bieron, Ph.D.

ARCADIA

ISBN 0-7385-1324-5

First published 2003

Published by Arcadia Publishing,
an imprint of Tempus Publishing Inc.
Portsmouth NH, Charleston SC, Chicago,
San Francisco

Printed in Great Britain

Library of Congress Catalog Card Number: 2003107818

For all general information, contact Arcadia Publishing:
Telephone 843-853-2070
Fax 843-853-0044
E-mail sales@arcadiapublishing.com
For customer service and orders:
Toll-free 1-888-313-2665

Visit us on the Internet at www.arcadiapublishing.com

CONTENTS

ACKNOWLEDGMENTS

Special thanks go to those who provided source material for this presentation: Ward Abbott, former resident of the David White farm, descendant of early families; Cynthia A. Adams, daughter of Clara Adams, a Potter descendant; Lucille Almendinger, restorer of the former Methodist church, Chestnut Ridge Road; Judith Baker Becker, descendant of the Baker and Freeman families; John Brookins, of the Brookins Greenhouse family; John Conlin, of *Western New York Heritage* magazine, for the log cabin photograph; Rev. Dennis Conrad, pastor of St. John's Lutheran Church; Ron Durcholz, collector; Erie County clerk's office, for the record of deeds; Timothy Gardner, curator of the Allen Potter museum; May Gotthelf, descendant of the Schluter family; Fred Lavin, collector; James Lockard, descendant of the Potter family; Louise Mayr, wife of Otto Mayr and descendant of Harry Yates; Rev. Lawrence Milby, pastor of Nativity of Our Lord Roman Catholic Church; the Orchard Park historian's office; the Orchard Park Historical Society; Sally Pyne, niece of former Police Chief William Martin; the Society of Friends, for minutes of early local meetings; *Southtowns Citizen* newspaper, Orchard Park; Charles L. Stoddart, Ph.D., superintendent of Orchard Park schools; Earl Trevett, descendant of several early families; Ruth A. Tubbs, former Orchard Park teacher, via Dr. Charles L. Stoddart; Elizabeth Yates, *A Tribute to Harry Yates*, courtesy Mrs. Philip Bachert; Harry Yates, "Yates Farms, Orchard Park, New York;" and Barbara Zielinski, a descendant of several early families.

INTRODUCTION

The first settlers in today's Orchard Park Township were Didymus C. Kinney, his wife, Phebe (Hartwell) Kinney, and their family. In October 1803, they purchased land in what is now the southwest corner of the township and built a cabin there. By 1811, they had moved on to Ohio. Soon afterward, this area became a destination for a tide of migrating Quaker families from communities in Vermont, eastern New York, and Pennsylvania. Agrarian Quakers preferred life in quiet communities that were detached from the "corrupting influences" of the larger world. The region was attractive to Quakers, including Jacob Lindley, who referred to it as an "uncultivated part of nature's garden."

In June 1804, two Danby, Vermont, residents, Ezekiel Smith and Quaker Amos Colvin, contracted for the purchase of large tracts of land located in the same southwest quadrant where the Kinney family had lived. Quaker David Eddy, also from Danby, moved to the area and, in October 1804, reserved all of Lots 7 and 15 of the property for $2.25 per acre. This land represents almost 600 acres, including much of present Orchard Park Village. Eddy reserved Lot 15 for his father and mother, Quakers Jacob and Susannah (Sprague) Eddy, and he reserved Lot 7 for himself and his wife, Hannah (Arnold) Eddy, as well as for other members of the Eddy, Arnold, Sprague, and related families. The Jacob Eddy family, including most of their grown, married children, came to the area c. March 1805. Jacob Eddy subsequently completed the purchase of all of Lot 15, containing 286 acres, with today's Four Corners of Orchard Park roughly at its center. The members of the Eddy family were central players in Orchard Park's early settlement.

In 1804, Joseph Ellicott informed the Holland Land Company that a road leading from Lake Erie through part of Township 9, in the 7th (now Orchard Park) and 8th (now Hamburg) Ranges, had been completed. This was key to settlement. It was eventually called the Middle Road and was later incorporated into Big Tree Road (Route 20A).

Quaker Obadiah Baker and his wife, Anna (Wheeler) Baker, had come from Danby, Vermont, in 1807, and within a few months, Quaker meetings at the dwelling house of Obadiah Baker were sanctioned. By 1811, there were more than 20 Quaker families, and by 1814, upwards of 25 Quaker families lived in the community. In December 1811, a half-acre property, "with a log house standing thereon," on the northeast corner of the Four Corners (today's village center) was purchased by the Society of Friends "for the sole purpose of building a meeting house thereon." The log house served the Friends until the early 1820s, when they built and occupied the picturesque meetinghouse known today. From all accounts, the original log house was the

first religious structure of any denomination in all of present-day Erie County. The pioneers were primarily Quakers. Surnames among them also included Chilcott, Deuel, Freeman, Griffin, Hall, Hoag, Hambleton, Hampton, Kester, Potter, Shearmen, Sprague, Tilton, and Webster. Some of these pioneers came from eastern Pennsylvania.

Although a society that valued its privacy, the Quakers coexisted cordially, cooperatively, and peacefully with non-Quaker pioneers. Early Quakers were strict and ever watchful over their fellow Quakers, lest they be tempted by any of the "evils that attended" the non-Quakers, and they discouraged marriage outside of the Quaker community. Surnames, in addition to Smith, that were among the early non-Quakers were Coltrin, Fish, Abbott, Bemus, Clark, Sheldon, Bradley, Newton, and Wright. Most of these families, like their Quaker counterparts, have descendants living in the area today.

The area we now know as Orchard Park Township was originally part of the township of Hamburgh. Early in its history, the area we know as the environs of the Four Corners of Orchard Park Village became known as Potter's Corners due to the homesteading of the prolific Quaker Potter family. A decision was made in 1850 to separate Hamburgh's east half from its west half, the new eastern township to be named Ellicott. This designation lasted for a little more than a year and was then changed to East Hamburgh. Potter's Corners was renamed Orchard Park in 1882, when it was noted that the community resembled a park of orchards. The community had been known as Orchard Park for many years before it officially was incorporated as village in 1921. Finally, the entire township of East Hamburg became known as Orchard Park Township in 1934, the final "h" of Hamburgh having been lost through the years.

In the early days on this frontier, responsibility for much of a child's education had to be assumed by the family. From an early age, the chores of the farm and household included a wealth of hands-on instruction. The first common schoolhouse that can be documented, the District No. 5 Schoolhouse, was constructed in southwest Orchard Park Township (then Hamburgh). The schoolhouse was built sometime prior to March 1820, when it was referenced as preexisting in a deed. It was located near the intersection of Bunting and Draudt Roads. Local Quakers were mindful that a "guarded education" for their children was desirable, but an exclusive school for Friends was not established until 1826. The minutes from a meeting held on December 28, 1825, reveal a request for "the privilege of building a schoolhouse on the meetinghouse lot." The concept was approved, and a log school was built in early 1826. This schoolhouse was built facing the present North Freeman Road on the grounds of the still-standing meetinghouse. David Eddy recalled that its first teacher was Henry Hibbard. It was in existence for only 10 years.

In 1854, Quaker John Allen and his wife, Chloe, purchased a large tract of land bordering the south side of West Quaker Street and the west side of South Lincoln Street. They built a boarding academy c. 1866 on 3.8 acres of this land, a plot that roughly coincides with the site of today's middle school minus the athletic field. The academy is said to have been "a long, handsome, three story building with dormitories and classrooms." In 1869, John and Chloe Allen sold the academy to the newly formed East Hamburgh Friends Institute, which operated it for more than a dozen years. In 1881, a wing of the building and a portion of the land were separated and deeded to East Hamburgh's Public School District No. 6. Within months of that sale, in April 1882, the remainder of the building, then being used for tenement housing, burned. A report of the fire stated: "The large building at East Hamburgh known as the Quaker Academy caught fire as supposed from a defective chimney and with the contents totally destroyed. Loss and insurance could not be ascertained. The loss, however, is estimated at $10,000." This was the final blow to the Friends' endeavors in local education.

As the community grew, links with neighboring communities improved. Dirt roads that had become plank roads in the 1840s were gradually upgraded to stone, brick, and macadam, especially after the invention of the horseless carriage. The railroad was extended to Orchard Park in 1883, and a small wooden depot was built just south of the Thorn Avenue crossing. In 1900, an electric trolley line was established between Buffalo and Orchard Park, a town of 800

people. The line was abandoned in 1932, when buses replaced the transportation aspect—but not the adventuresome thrill—of trolleys.

By 1851, a series of events led the Seneca Native Americans to give up their Buffalo Creek Reservation, part of which lay north of East Hamburg, specifically, all of present-day Orchard Park Township located north of Webster Road. Township lines were redrawn, and all of that land was opened to settlement by white investors. This coincided with an influx of German immigrants escaping tyranny and unrest in Germany. Many of these new immigrants discovered this land that was formerly the Buffalo Creek Reservation, and before long, a sizeable German community was established in the northeastern part of Orchard Park. Also during that period, many Germans settled on farms to the south of Orchard Park Village.

With the advent of fast and convenient transportation, the farming community of Orchard Park began to see more city folk arriving as residents in the 1900s. The Irish of south Buffalo were the first to come down from the north, and Orchard Park soon became a bedroom community of Buffalo. Greater attention to social and cultural affairs ensued.

No history of Orchard Park would be complete without mention of Harry Yates, Orchard Park's greatest single benefactor. A section of this book is dedicated to him.

In the years since its beginning, Orchard Park has seen many changes, yet the area is still somewhat rural, with many farms and expanses of land. Along with a serene lifestyle, the community has the advantages of a superior centralized school system and many cultural opportunities, such as the Orchard Park Symphony, the summer pavilion, and the Quaker Arts Festival. The pioneering ancestors had a dedication to labor and duty that cannot be overestimated, and their footprints have left an indelible impression on the character of the community. They brought with them an estimable work ethic, a strong sense of fairness, and a spirit of community harmony. They transformed a vast wilderness into an inviting settlement. They left a legacy of graceful, functional landmarks built as their residences, churches, and public places, which now speak of their culture, lifestyle, and values, giving character to the local byways and serving to inspire modern likenesses.

—Suzanne S. Kulp
Town and village historian
May 2003

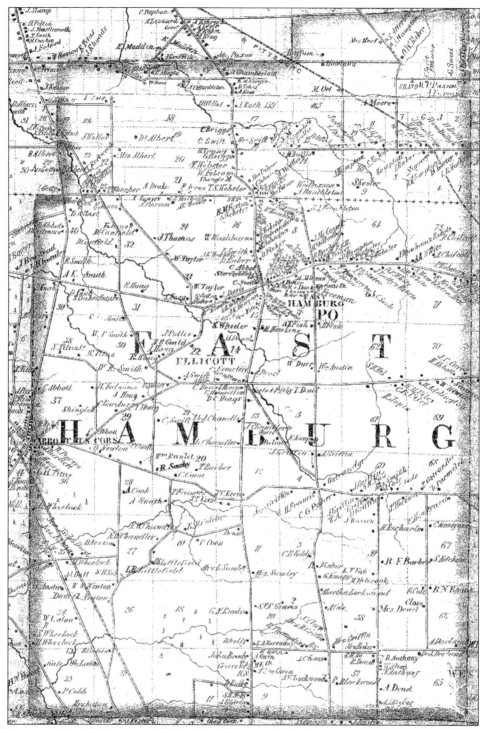

This map is from Robert Pearsall Smith's 1855 map of Erie County.

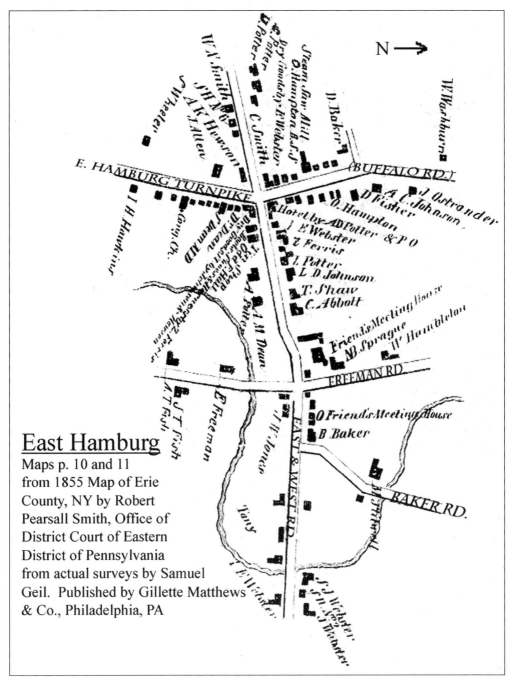

N →

East Hamburg

Maps p. 10 and 11
from 1855 Map of Erie
County, NY by Robert
Pearsall Smith, Office of
District Court of Eastern
District of Pennsylvania
from actual surveys by Samuel
Geil. Published by Gillette Matthews
& Co., Philadelphia, PA

This map also comes from Robert Pearsall Smith's 1855 map of Erie County.

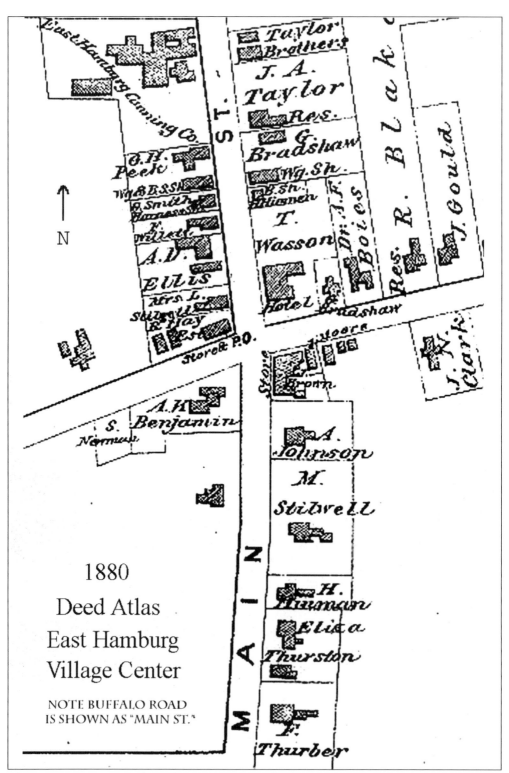

1880
Deed Atlas
East Hamburg
Village Center

NOTE BUFFALO ROAD
IS SHOWN AS "MAIN ST."

This in an overview map from the *Beers 1880 Deed Atlas*.

One
THE FOUR CORNERS

A tour of the Four Corners of Orchard Park begins with this view, looking west from the plank sidewalk along the south side of East Quaker Road. The buildings all date from 1860 or before. From 1855 to 1866, those on the left housed Dr. Dorland's office; Zebulon Ferris's Boots, Shoes, & Harness shop; a building owned by Allen Potter with a first-floor tin shop, and Johnson & Hewson's Dry Goods Store. By 1866, Charles Hewson's name was no longer associated with the store, leaving the business to Ambrose C. Johnson. Also shown are the Potter building (center background) and the East Hamburg Hotel (right).

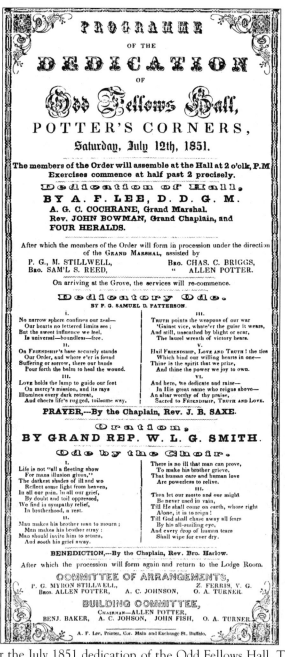

PROGRAMME

OF THE

DEDICATION

OF

Odd Fellows Hall,

POTTER'S CORNERS,

Saturday, July 12th, 1851.

The members of the Order will assemble at the Hall at 2 o'clk, P.M.
Exercises commence at half past 2 precisely.

Dedication of Hall,

BY A. F. LEE, D. D. G. M.

A. G. C. COCHRANE, Grand Marshal.
Rev. JOHN BOWMAN, Grand Chaplain, and
FOUR HERALDS.

After which the members of the Order will form in procession under the direction
of the GRAND MARSHAL, assisted by

P. G., M. STILLWELL, BRO. CHAS. C. BRIGGS,
BRO. SAM'L S. REED, " ALLEN POTTER.

On arriving at the Grove, the services will re-commence.

Dedicatory Ode.

BY P. G. SAMUEL D. PATTERSON.

I.

No narrow sphere confines our zeal—
Our hearts no lettered limits see ;
But the sweet influence we feel,
Is universal—boundless—free.

II.

On FRIENDSHIP'S base securely stands
Our Order, and where e'er is found
Suffering or sorrow, there our hands
Pour forth the balm to heal the wound.

III.

LOVE holds the lamp to guide our feet
On mercy's mission, and its rays
Illumines every dark retreat,
And cheers life's rugged, toilsome way.

III.

TRUTH points the weapons of our war
'Gainst vice, whate'er the guise it wears,
And still, unscathed by blight or scar,
The laurel wreath of victory bears.

V.

Hail FRIENDSHIP, LOVE AND TRUTH ! the ties
Which bind our willing hearts in one—
Thine is the spirit that we prize,
And thine the power we joy to own.

VI.

And here, we dedicate and raise—
In His great name who reigns above—
An altar worthy of thy praise,
Sacred to FRIENDSHIP, TRUTH AND LOVE.

PRAYER,---By the Chaplain, Rev. J. B. SAXE.

Oration,

BY GRAND REP. W. L. G. SMITH.

Ode by the Choir.

I.

Life is not "all a fleeting show
For mans illusion given,"
The darkest shades of ill and wo
Reflect some light from heaven,
In all our pain, in all our grief,
By doubt and toil oppressed,
We find in sympathy relief,
In brotherhood, a rest.

II.

Man makes his brother man to mourn ;
Man makes his brother stray ;
Man should invite him to return,
And sooth his grief away.

There is no ill that man can prove,
To make his brother grieve,
That human care and human love
Are powerless to relive.

III.

Then let our motto and our might
Be never used in vain,
Till He shall come on earth, whose right
Alone, it is to reign !
Till God shall chase away all fears
By his all-smiling eye,
And every drop of human tears
Shall wipe for ever dry.

BENEDICTION,---By the Chaplain, Rev. Bro. Harlow.

After which the procession will form again and return to the Lodge Room.

COMMITTEE OF ARRANGEMENTS,

P. G. MYRON STILLWELL, Z. FERRIS, V. G.
Bros. ALLEN POTTER, A. C. JOHNSON, O. A. TURNER.

BUILDING COMMITTEE,

CHAIRMAN—ALLEN POTTER,
BENJ. BAKER, A. C. JOHNSON, JOHN FISH, O. A. TURNER.

A. F. Lee, Printer, Cor. Main and Exchange St. Buffalo.

This program was for the July 1851 dedication of the Odd Fellows Hall. The hall was located on the second floor of Allen Potter's building, above the tin shop. The Odd Fellows leased the space for $47 per year. In addition to entrepreneur Allen Potter, others mentioned in the program were Ambrose C. Johnson, a businessman; Zebulon Ferris, a saddle and harness maker who later became surrogate judge of Erie County; Myron Stilwell, a horticulturist; Orsamus A. Turner, a historian and the author of *Pioneer History of the Holland Purchase*; and Samuel S. Reed, the proprietor of the stagecoach between Buffalo and Deuel's Corners, who, in 1870, moved to Salt Lake City where he ran a six-horse stagecoach from Salt Lake City to Deer Lodge, a distance of about 600 miles.

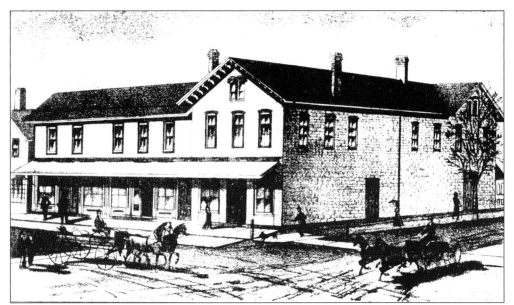

By 1880, Jeremiah Brown (1842–1898) was proprietor of the former Ambrose C. Johnson general merchandise store on East Quaker Road, apparently leasing the building from Ambrose Johnson, who had built his Italianate-style home directly behind the store. This sketch of the building appeared in the 1880 *Beers Atlas of Erie County*. In 1892, Brown "assigned all effects for the benefit of creditors to Henry H. Persons, assignee of Jeremiah Brown."

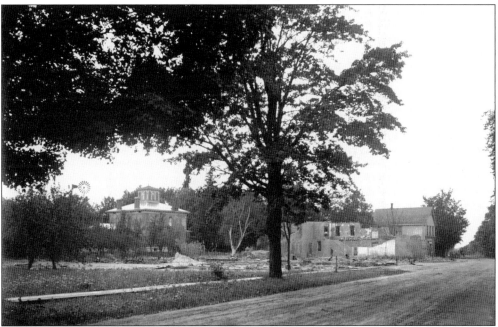

A fire consumed the southeast corner of the village center in December 1902. The Johnson mercantile building, another store, and other structures, including the original barn on the Johnson-Jolls property, were lost. The Johnson-Jolls house, on South Buffalo Street, is seen on the left. Dr. Willard Burton Jolls pumped water from his well (note the windmill) to wet the roof of his home, saving it from the fire.

15

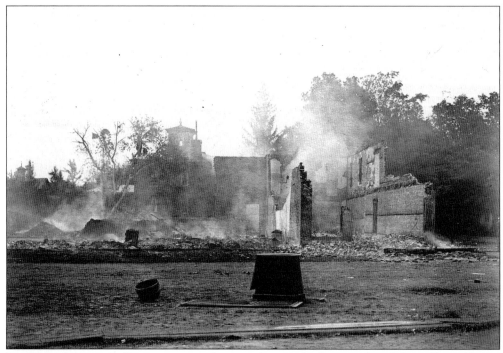

Dr. Willard Burton Jolls, an amateur photographer, took photographs of the still-smoldering ruins after the December 1902 fire. The cupola of his house can be seen in the background.

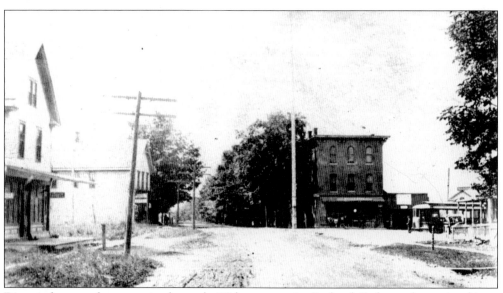

Dirt roads were the norm in the early 20th century in Orchard Park, as shown in this c. 1903–1908 photograph. On the left is a new building, constructed on a portion of the site leveled by fire in 1902. In the center of the Four Corners intersection is the liberty pole, installed in 1868. On the far right, a trolley car approaches the Four Corners. In the left background is a c. 1900 building that still stands, on the southwest corner of South Buffalo and East Quaker Roads.

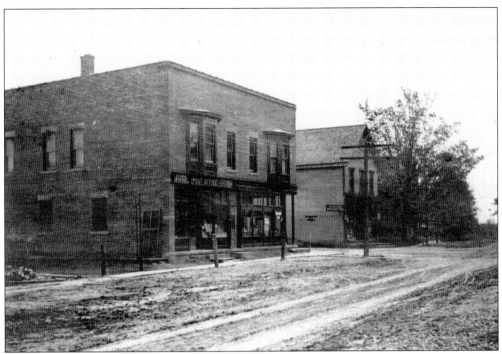

A brick building replaced the burned mercantile building *c.* 1905. The sign over the nearby store reads, "A.K. Hoag, Insurance, Fire-Life-Accident, Post Office, School Supplies-Stationery." The second store has no sign. A sign on the far building, across South Buffalo Road, reads "Non-Proprietary Drugs & Medicines." It is known that Anthony & Ormsby Drugs and Medicines was in that building *c.* 1908.

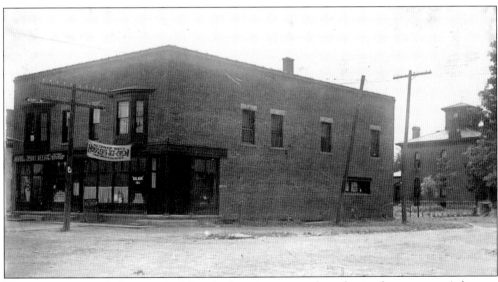

The corner store of the new building had an ice-cream shop for its first tenant. A banner reading, "Hoefler's Ice Cream, Received Daily from Buffalo NY" is seen. A sign for Salada tea is posted in the window. There was no side entrance in the building at this time. The post office is still found in this store. Note the Johnson-Jolls house in background.

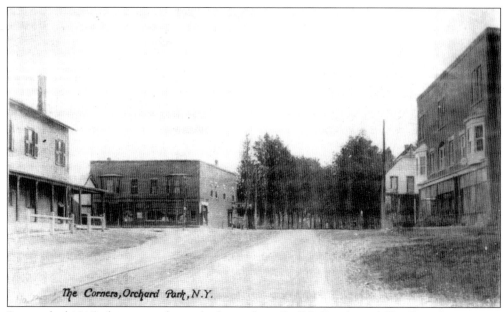

Postmarked 1915, this postcard view looks south on Buffalo Road across the Four Corners.

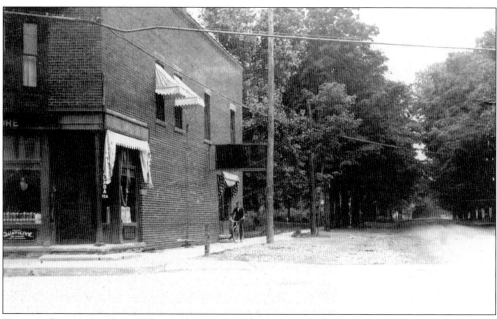

Trees arch over South Buffalo Street, seen as a dirt road in this photograph postmarked 1917. There is now a side entrance to this building.

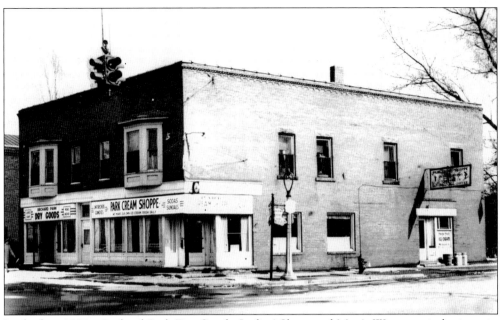

In the late 1930s, Orchard Park Dry Goods, Ladies' Shop, and Men's Wear was in business in the building to the left, while on the right was the Park Cream Shoppe, whose sign read, "We Make Our Own Ice Cream Daily – Unterecker Candies, Sodas, Sundaes, Coffee." The ice-cream shop operated until after World War II. Note the milk cans by the side door and the sign pointing to Chestnut Ridge Park, the first Erie County park.

The front corner of Anthony & Ormsby, today's Frame 'n Save building, is on the left in this photograph looking out to West Quaker Road from the Four Corners c. 1910–1915. Note the second business, the gasoline pump next to the road with the sign advertising gasoline, and the end of the word Firestone on the building. The third building is W.G. Arthur's new hardware store, and beyond are a wagon shop, a blacksmith shop, Lemuel Cook's funeral home, and the fire hall. The latter four were destroyed, and the Arthur building badly damaged, in the fire of December 1918.

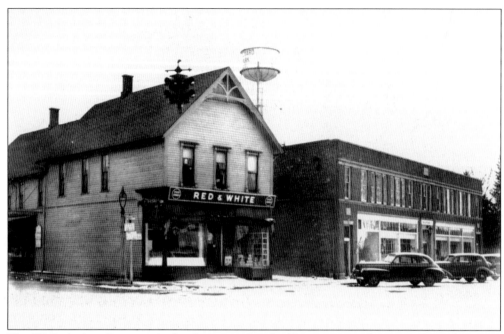

The W.G. Arthur Company built a larger modern building in 1921, shown on the right in this photograph. Andrew "Buster" Brown and his wife, Minnie Brown, began operating the Red & White grocery store in the corner building in 1921. The Browns lived above the store. This photograph dates to the early 1940s. Early deeds and Quaker records from 1817 through 1825 indicate that the first building on this corner was an establishment where "spirituous liquors" were sold by John Eddy, who with his wife, Harriet, also resided in the building. A footprint of the building appears on the 1855 map on page 11, showing the occupant at that time to have been Archibald K. Hewson.

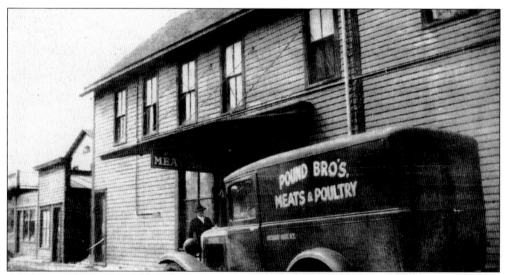

A side entrance to the building from South Buffalo Road was used to enter the Pound Brother's Meat Market, located in the rear of Brown's Red & White. This photograph dates from the early 1930s.

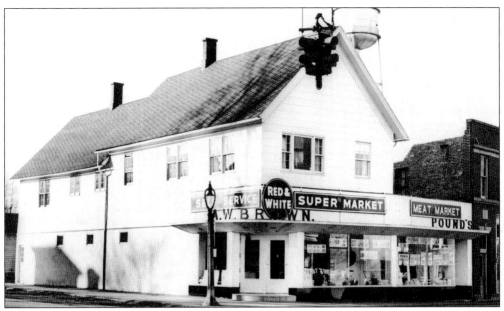

During the 35 years they owned the Red & White, Buster and Minnie Brown remodeled their upstairs living quarters, redesigned and expanded the storefront, and placed Pound's Meat Market in a new addition to the right of the old building. The Browns operated both until the Super Duper grocery store opened, in 1955, on North Buffalo Road, at which time Brown became receiver of taxes for Orchard Park.

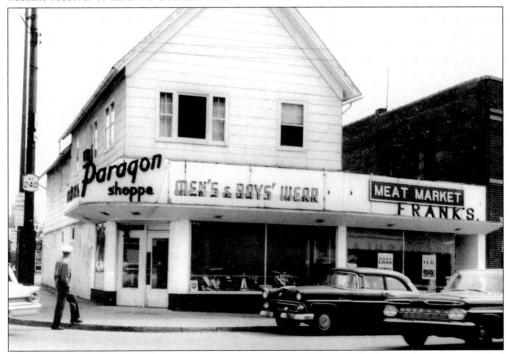

The Anthony and Mary Alico family business, Paragon Shoppe Men's & Boys' Wear, moved into the corner building in 1956, operating as a haberdashery through 1977. Frank Wnek was operating the meat market at the time of this 1960s photograph.

In this view, looking out at West Quaker Road from the Four Corners *c.* 1909–1915, the new Briggs Building is on the right.

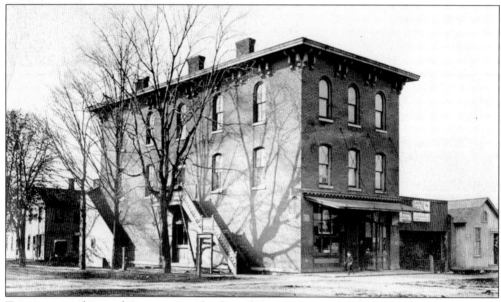

Two acres on the northwest corner of today's West Quaker and Buffalo Roads were originally sold by Jacob Eddy to the Quakers in 1811 "for the sole purpose of a burying place for their dead," according to Erie County deeds. In 1823, the Quakers sold the 1.5 acres closest to the corner, and they maintained a half-acre burying ground until 1854, when it too was sold. Later in the century, Levi Potter (1818–1878), in partnership with George W. Sweet, owned the land, on which the building pictured here was built. In September 1860, Sweet sold his share to Potter, who at that time was a dealer in dry goods and groceries. Potter, a founding member and first master of the Zion Masonic Lodge in East Hamburg, rented the top floor of this building to the lodge at a rate of $50 per year beginning in 1861. Potter and his family moved into the rooms over the store in September 1863. Partners in his mercantile business were Christopher Hambleton and John Scott.

In 1868, claiming trade was dull in East Hamburg, Levi Potter sold the business and building to his partners. The structure then became known as the Hambleton Building. Potter first moved to Buffalo and then to Chicago. He had served East Hamburg as town clerk, supervisor, and postmaster, and in 1866, he became one of four elected representatives from Erie County in the state assembly.

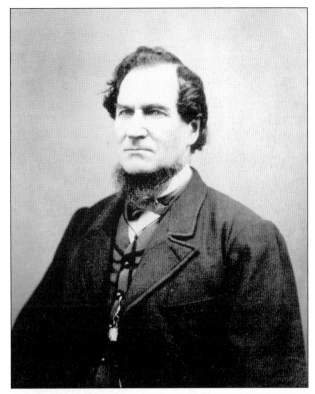

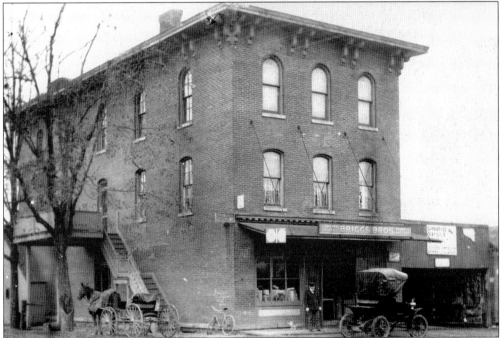

The Briggs brothers, Frank and Arthur, ultimately acquired the building and mercantile business that had once belonged to Levi Potter. Note the three modes of transportation shown here: horse and buggy, bicycle, and horseless carriage.

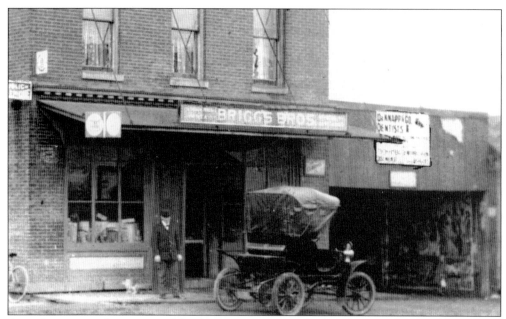

An enlargement of a section of the former picture reveals that the awning sign in this early-1900s photograph reads "Briggs Bros.," and the large sign over the opening to the right reads "Dr. Knapp & Co. Dentists." This was likely the office of H. Lester Knapp, D.D.S. (1867–1936), son of Gershom and Polly (Gwin) Knapp. The small sign to the left of the awning announces a public telephone. In 1889, when this was the Hambleton Building, the telephone here was the only one in town. The horseless carriage in this scene was manufactured sometime between 1903 and 1908. This building and adjacent buildings burned in 1908.

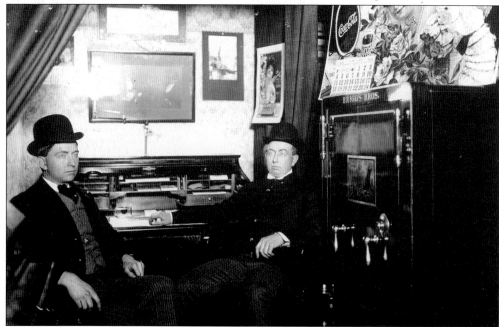

This photograph of Frank Briggs (1871–1965) and Arthur Briggs (1874–1955), owners of Briggs Brothers, was taken in their office in 1903. Note the roll-top desk and large safe.

24

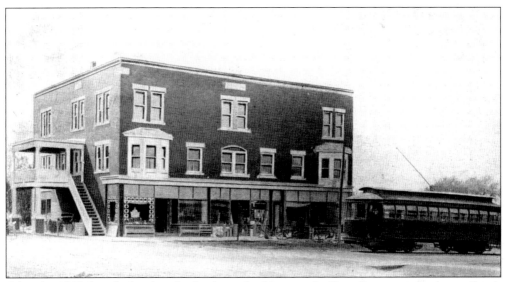

After the 1908 fire, the brothers built a larger building on the Four Corners site to house Briggs Mercantile Company. Notice the trolley, which served Orchard Park from Buffalo between 1900 and 1932.

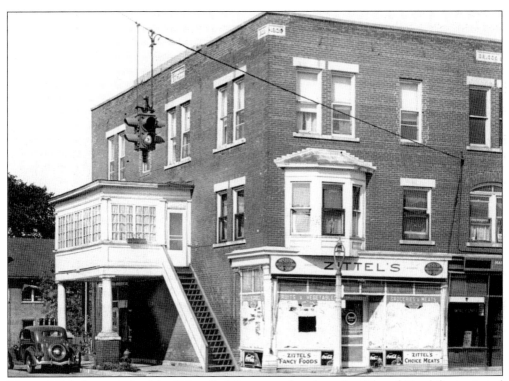

This *c.* 1935 photograph of the Briggs Building was taken just after Edward Zittel discontinued his business, Zittel's, a fancy foods and choice meats establishment.

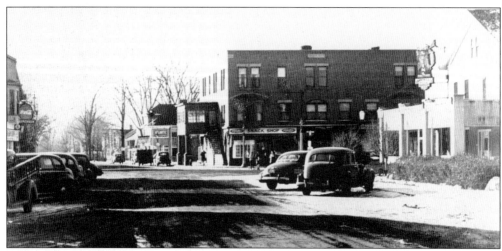

In this view looking west toward the Four Corners *c.* 1940, the Briggs Building is in the right rear and Stein's Hotel is in the right foreground. Note the diagonal parking, which was popular at that time. A delicatessen and snack shop, which served Rich's Ice Cream, occupied the store on the corner; Marshall-Besch Insurance was in the next storefront; and Anthony Brown Pharmacy was the third shop, barely visible here. The snack shop and then Arlotta's grocery store occupied the corner storefront until 1955, when Anthony Brown Pharmacy moved to that space. In 1975, the pharmacy moved to its present South Buffalo Road location. Note the interesting street lamp.

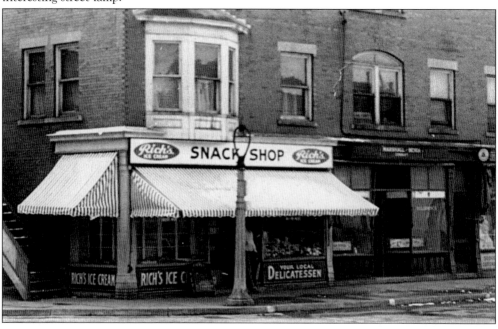

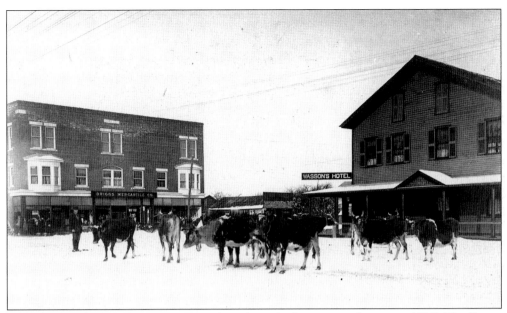

What better place to drive your cows than through the center of town in 1916! The Briggs Building is on the left, across Buffalo Road, and Wasson's Hotel is on the right.

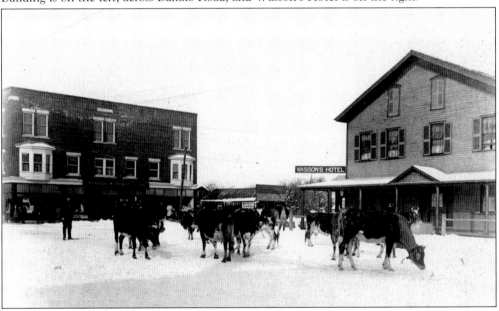

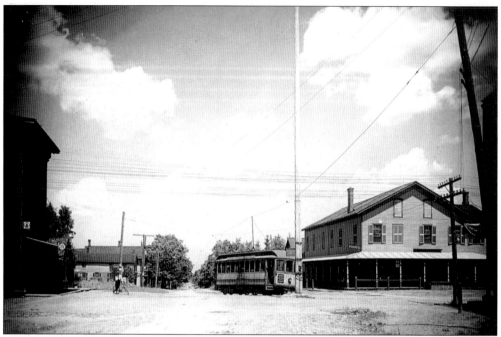

This view looks north on Buffalo Road, through the Four Corners, c. 1904–1908. The bicyclist is William Haag, later an Orchard Park policeman. His home, directly behind him, still stands just north of the bowling alley entrance. The well-known Wasson's Hotel is on the right. Before heading back to Windom, the trolley circled the 1868 liberty pole, which stands in the center of the intersection.

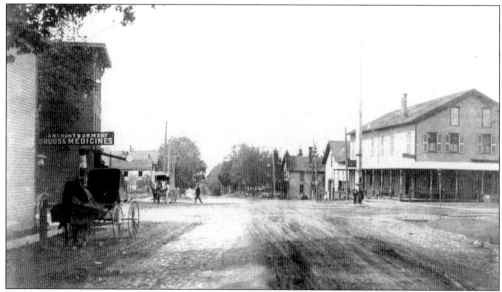

This postcard view looks north from Buffalo Road through the Four Corners. The message, written on August 12, 1908, indicates that the population of East Hamburg is 860. The sign on the building to the left reads "Anthony and Ormsby, Drugs and Medicines." Later, this became Anthony and Stone and then Anthony Brown. The original Anthony was a great-great-grandfather of pharmacist Randy Brown of Anthony Brown Pharmacy.

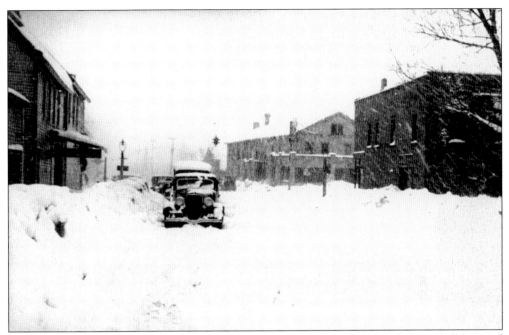

Pound Brother's Meat Market is seen on the left in this view looking north from Buffalo Road through the Four Corners after an early 1930s snowstorm. It appears to be the Pound Brother's delivery truck that is mired in the foreground.

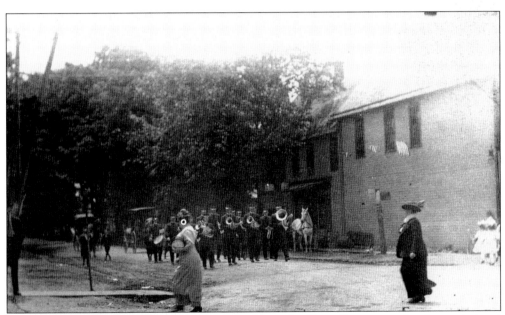

Some women hurry across South Buffalo Road at the Four Corners as the firemen's band approaches during the May 1913 Decoration Day parade.

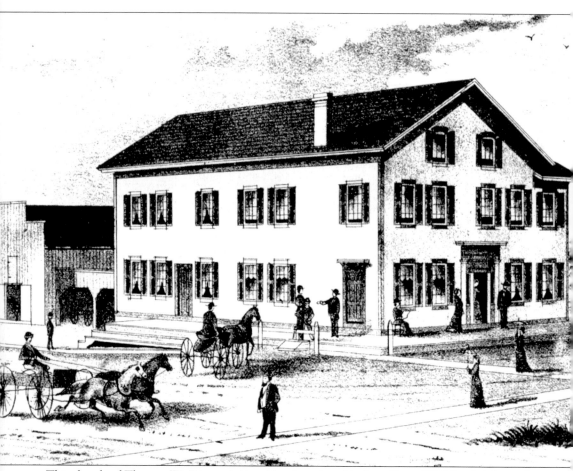

This sketch of Thomas W. Wasson's East Hamburg hotel is from *Beers 1880 Deed Atlas* and is the earliest known image of the establishment. The hotel sat on the site of the first church of any denomination in Erie County, which was the log house that was sold to the Society of Friends by David Eddy for $20 in 1811. The log structure served the Friends until they moved into their new meetinghouse c. 1821, at which time they sold this site to Lewis Arnold. There is evidence that Arnold developed a tavern here sometime between 1821 and 1824. Names associated with the ownership of the tavern property subsequently included Samuel Abbott, Joshua Potter, Allen Potter, Abner Potter (and his minor heirs), Henry Michael, and Henry Tillou. The latter's daughter, Mary Lavina Tillou Edwards (c. 1842–1905), inherited the tavern and, in 1874, married Thomas Wasson (1848–1914). Hence it became Wasson's Hotel (or Wasson House) with Mary Wasson as landlady, Thomas Wasson as hotel proprietor, and Mary's son by a first marriage, William H. Edwards (1861–1937), as bartender. The Wasson House operated through 1914. Note the liberty pole in the middle of the Four Corners, and the carriage shelter and livery stable behind the building.

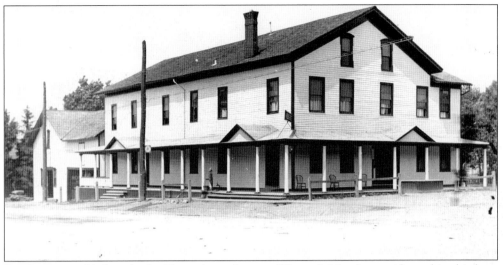

Porches were added to the building after it became Wasson's Hotel, as evidenced in this late-19th-century photograph. The overview map from the *Beers 1880 Deed Atlas*, shown on page 12, illustrates the building's configuration, with a northeasterly wing not visible in this image. The livery stable can be seen in the rear.

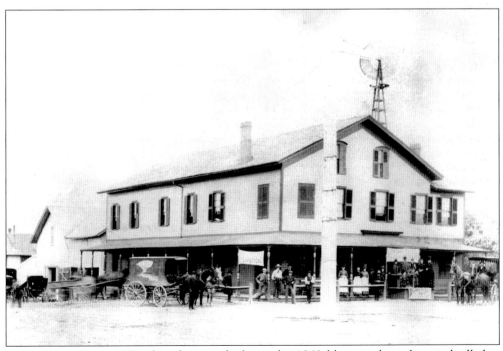

Taken just prior to 1900, this photograph shows the 1868 liberty pole and a windmill that pumped water for Wasson's Hotel.

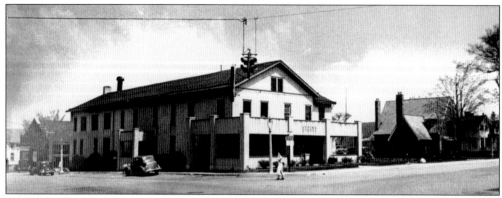

After Wasson's death in 1914, Edward Stein (1873–1946) purchased the building and business, and it became Stein's Hotel. He extended the building, remodeled it to this appearance in 1916, and added an open porch around the front. This photograph is from the late 1930s. Stein sold the building in 1946.

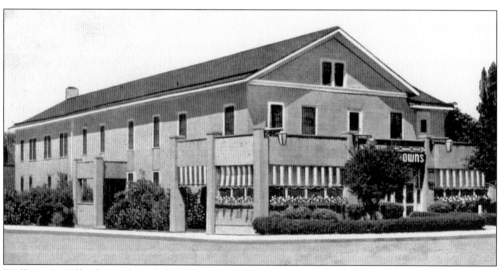

William R. Ullrich purchased the Edward Stein property in 1946. Ullrich was 27 at the time, the youngest person in Erie County to hold a liquor license. He remodeled the hotel, screened the front porch, and reopened it as the Orchard Downs restaurant, a name that endured. He sold the restaurant and retired in 1961. He died in 1994.

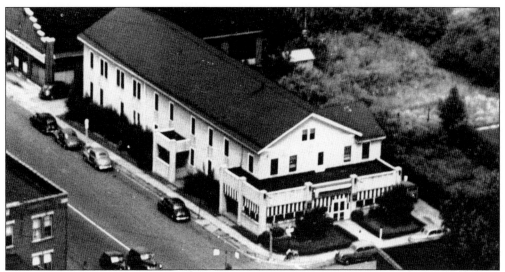

This aerial view of the Orchard Downs, advertised as "the Inn of Tradition," was taken *c.* 1950. At some point, the second floor no longer met fire codes and was closed to the public, although the beautiful balustered stairway remained. The former hotel rooms were small but interesting, with glassed transoms over the entrance doors.

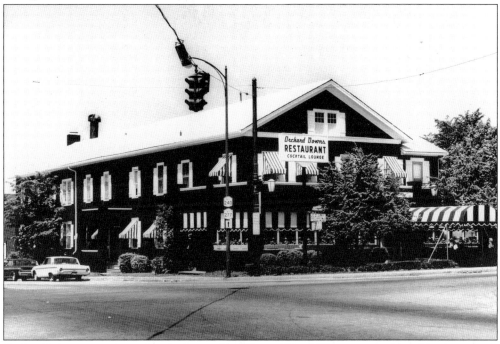

Orchard Downs was owned and operated by Hiram "Pete" Harrington when this photograph was taken *c.* 1960. The building was painted green to match the awning stripes, and the front porch was used for seasonal dining. Frank Shores bought the restaurant in 1961 and eventually enlarged and converted the former front porch for year-round use, added air conditioning to the restaurant, and maintained a reputation for "fine food in a refined atmosphere." After Shores retired, subsequent owners experienced financial problems, and the aged building needed extensive work to meet modern codes.

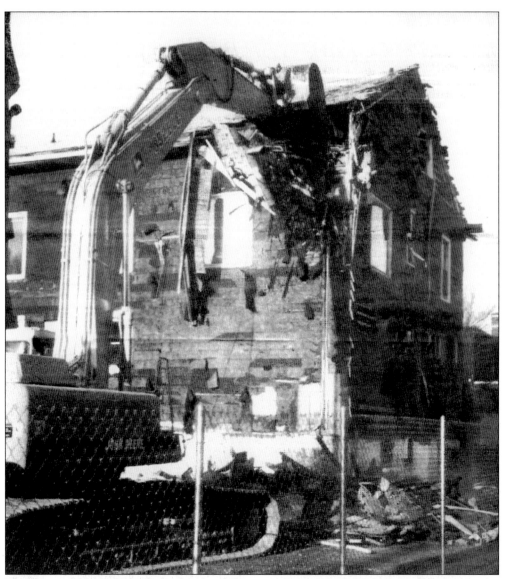

The historic Orchard Downs had endured for some 180 years, through wars, depressions, the gold rush, the Underground Railroad, women's suffrage, Prohibition, multitudes of technological and medical advances, and many other events. It had seen fires destroy the buildings on the other three corners of the Four Corners, and it had been spared. Sadly, it could not survive a demolition crew. It was destroyed on April 18, 2001.

Two

ORCHARD PARK IS NAMED

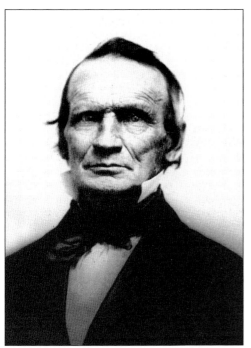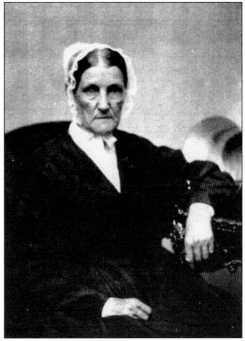

Jacob Potter (1796–1880), son of pioneer settler Nathaniel Potter (1760–1842), came to this frontier at the age of 13 in 1809 with his widowed father and 10 siblings. In 1815, his father remarried the widow Mary Cooper Jenks (1776–1845), who moved into Nathaniel's Duerr Road home with her seven children. Ultimately, Jacob Potter married one of his stepmother's daughters, Alma Jenks (1798–1875), and acquired about half of his father's acreage. The Potters were all Quakers (note Alma's Quaker bonnet).

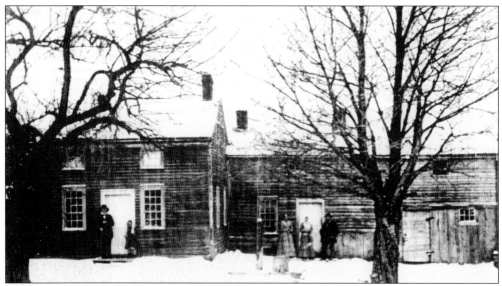

These are the house and farm buildings that Jacob and Alma Potter built. They raised their six children, including Donna Byance Potter, here. The family called the property Potter Brook Farm. In 1855, Donna Byance Potter married Job Taylor, and they continued to live at the farm while raising their two daughters, Estelle and Donna Eloise. An elderly, white-bearded Jacob Potter stands at the front door. He died in 1880. The others are unidentified. The 1865 census indicates that the farm included 150 apple trees "in fruit."

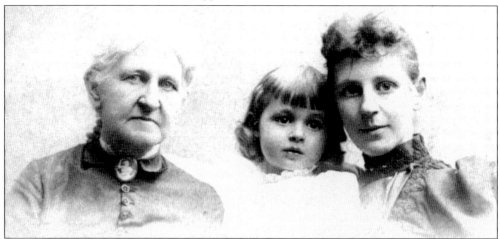

Pictured are the "three Donnas"—grandmother Donna Byance (Potter) Taylor (1822–1896), her granddaughter Donna Marie Thornton (1888–1968), and her daughter Donna Eloise (Taylor) Thornton (1864–1897). Donna Marie Thornton continued the naming tradition when she named her daughter Donna Elizabeth Lockard. Donna Byance Taylor was a schoolteacher and has been credited with naming the village of Orchard Park, formerly East Hamburg. Since the village's mail was constantly being sent to the town of Hamburg, a new name was desirable. Observing the orchards on and near Potter Brook Farm, and throughout the community, Donna Byance Taylor thought it looked like a park of orchards. With the encouragement of others, she contacted the postmaster general in Washington, D.C., in 1882 to arrange the name change. The township's name was changed from East Hamburg to Orchard Park many years later.

36

Job Taylor (1831–1901), the husband of Donna Byance Taylor, was proprietor of the East Hamburg Hotel c. 1860. Taylor's Hall was located in the hotel. Taylor also owned a little building on West Quaker Street (in the area where today's Ricotta's Pizzeria is located) where the first permanent library was established. He was a principal in the conversion of a steam sawmill on the west side of North Buffalo Road into a canning factory in 1878. The factory exploded and burned in 1889. In addition, Taylor was one of two original members to be initiated and raised in the Zion Lodge of Free and Accepted Masons.

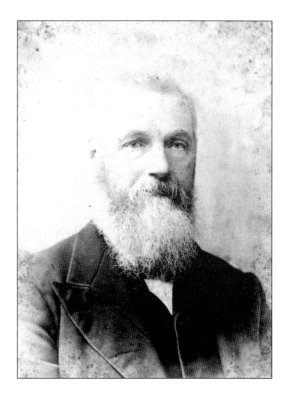

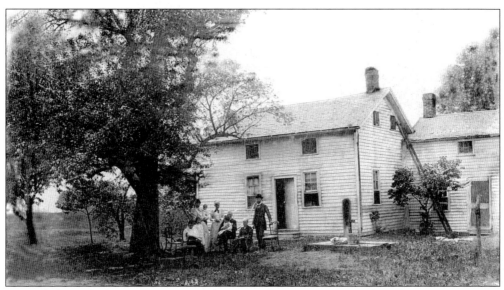

Painted white, the house at Potter Brook Farm is the setting for a family gathering one summer c. 1895. The Taylors' daughter, Donna Eloise Taylor, who had married Dr. William H. Thornton (1857–1927) in 1886, and her family were visiting from Buffalo. The house still stands at 4536 Duerr Road.

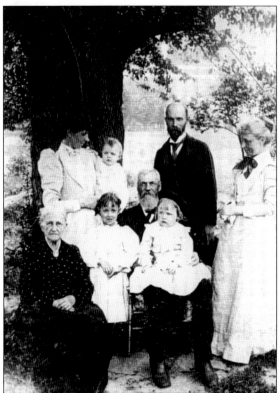

The family gathers under the old shade tree on a summer day c. 1895. From left to right are the following: (seated) Donna Byance (Potter) Taylor, Donna Marie Thornton, and Job Taylor (holding Irving T. Thornton); (standing) Donna Eloise (Taylor) Thornton (holding Alice Louise Thornton), Dr. William H. Thornton, and Estelle Taylor. Dr. Thornton counted two presidents among his patients: Grover Cleveland and William McKinley.

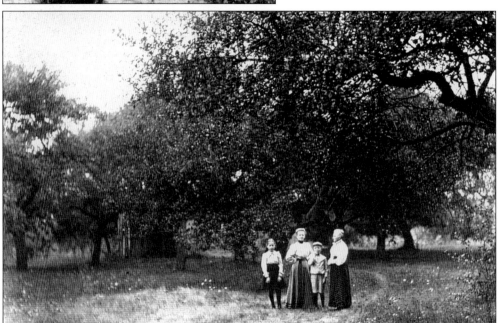

Shown c. 1899 in Potter Brook Farm's orchard are, from left to right, Donna Marie Thornton; her mother, Donna Eloise (Taylor) Thornton; her brother Irving Thornton; and her aunt Estelle Taylor. Potter Brook Farm orchard is one of those that inspired the community's name, Orchard Park, in 1882.

Three
BUSINESSES

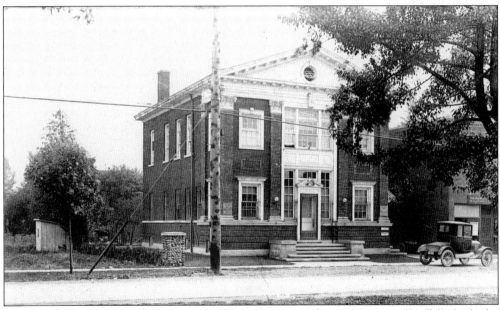

Local contractor John Bachman, using a plan of Lansing, Bley and Lyman of Buffalo, built the Bank of Orchard Park in 1916. It was the first lending institution in the community, begun with $30,000 in capital. The original directors were Lewis Willet, Mason Holmwood, Albert C. Dudley, William G. Arthur, Frank Holmwood, George Wasson, Colon J. Dudley, John Bachman, and Henry R. Stratemeier. This handsome Greek Revival building near the Four Corners now houses the local newspaper, the *Citizen*.

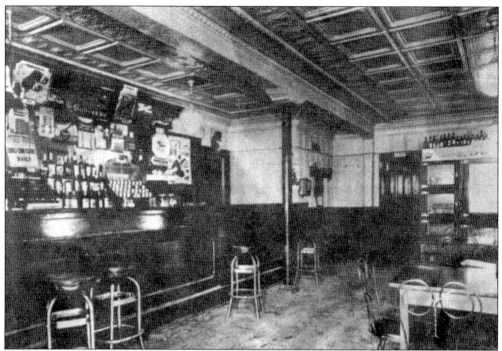

Jack and Alice Hutton purchased the hotel-restaurant business on the south corner of North Buffalo Road and Princeton Place in 1947, when the bar appeared as it does in this photograph. The signs indicate that chili con carne was served daily, and Bromo Seltzer and razor blades were displayed and sold.

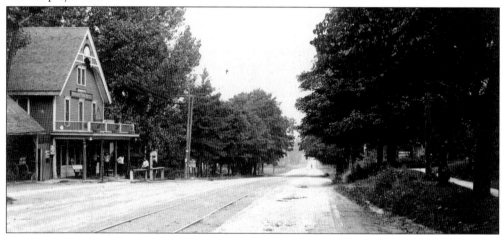

This view is looking north from North Buffalo Road in the very early 1900s. The building on the left is the hotel-restaurant referred to above. John Strebel, a farmer who came from Germany, built the building in 1836 and named it the Farm Stop. Later, he sold it to Art Finch, who owned it for less than a year before selling to Frank Johnson. Johnson owned the business for 40 to 50 years before the Huttons came along. The business reflected its owners' names—Strebel's, Finch's, Johnson's, Hutton's—until the 20th century, when it became the Orchard Park Hotel. It has recently been restored and remodeled into professional offices. The upper line of the sign cannot be read (it probably says Johnson's), but the lower line reads Orchard Park Hotel.

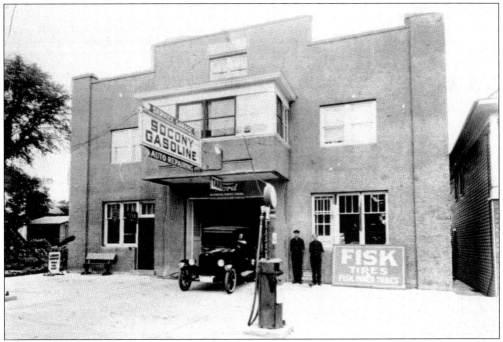

Ed Plisk's garage was one of the few places in Orchard Park where automobile owners in the 1920s and 1930s could get service for their newly acquired machines. Plisk's sold gasoline (note the gas pump in the foreground), repaired tires, and cleaned spark plugs while customers waited—all for 5¢. Plisk's also became a Ford dealership. Many area young men who were interested in motors and cars got their start working at Plisk's, among them the late Ray Carrow, who founded Carrow Chevrolet.

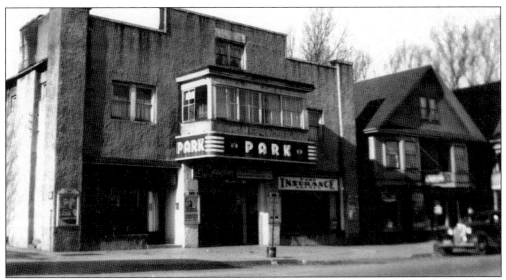

The Park Theater opened c. 1944 in the former Plisk garage building. During World War II, gasoline was rationed and television was still in the developmental stages. Local people frequented this theater for their entertainment. The building closed in the early 1960s. Reopened subsequently as other businesses, today, it is the Quaker Room banquet facility.

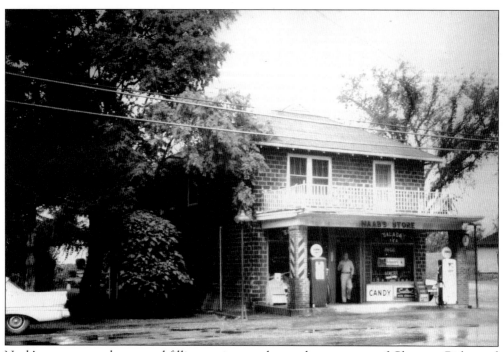

Naab's was a general store and filling station on the southwest corner of Chestnut Ridge and old Armor Roads. It was built in the early 1920s.

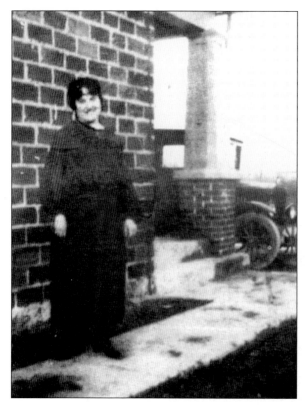

Eva Naab is seen standing beside the family business c. the 1920s. Note the old car with wooden-spoked wheels.

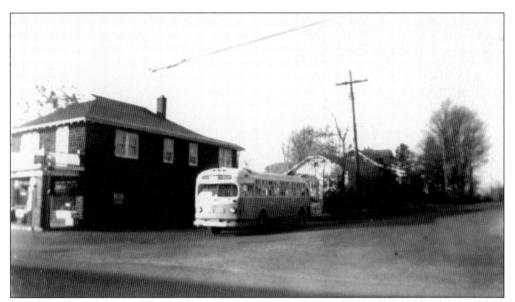

Naab's store and the Kendall gas station were the end of the line for the Seneca Street bus. Armor Road is on the right, and Chestnut Ridge Road is on the left. The bus would turn around here and head back into downtown Buffalo.

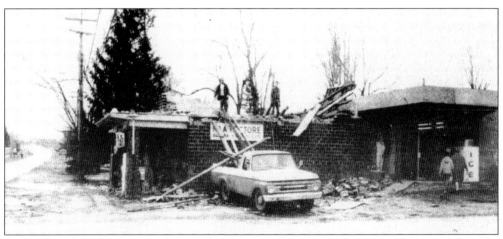

A casualty of the Chestnut Ridge Road widening in March 1964 was Naab's store. Before the demolition, Naab's built a new store immediately behind the old one, which is shown in operation on the right. The Naab family sold the business in 1971 to the families of John and Tom Bihr. Although recently sold again, the business still carries the Bihr name.

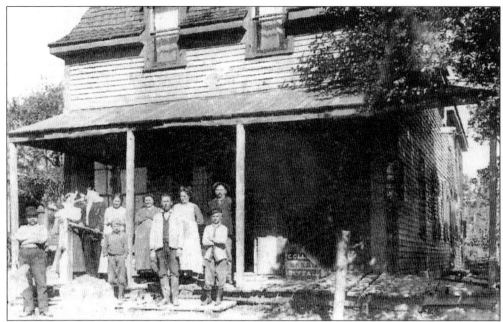

This building of solid plank construction stood on the northwest corner of South Buffalo and old Armor Roads. Maps show that the Union Store was housed here from 1855 to 1866. Through the years the structure has had various owners. Reportedly, at one time the Hood family lived there. Mr. Hood was in the business of acquiring wild horses from the Midwest, shipping them on the railroad, herding them to this location, and auctioning them in the sheds and outbuildings on this property.

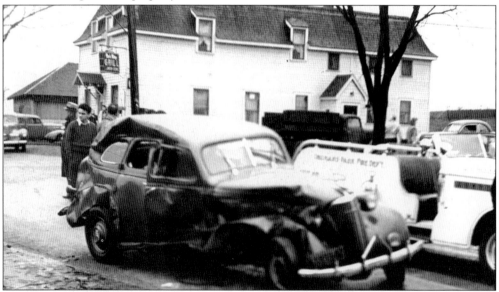

In 1906, Louis Schroder purchased the building, which then housed a tavern. He continued to operate the tavern until Prohibition. In 1926, his sister-in-law Emma Schroder purchased the building, and in 1934, Martha Schroeder Eckl and her husband, Jack Eckl, reopened the tavern-restaurant. The photograph shows the building in the background of a 1941 accident scene. Its sign reads "Park Ridge Grill Jack Eckl."

Martha Eckl remodeled the upstairs living quarters *c.* 1955 and raised a full dormer between the front windows. The front of the building faced old Armor Road.

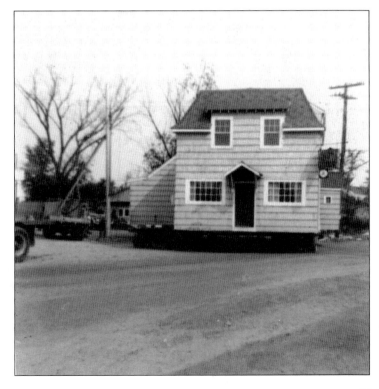

Another casualty of the widening of South Buffalo and Chestnut Ridge Roads was Eckl's Park Ridge Grill, condemned by the state, as it was too close to the road. In 1963, Martha and Jack Eckl's son Dale Eckl moved the restaurant building in its entirety, without so much as taking the dishes off the shelves. The move to the new location, on Ellicott Road, was smooth and successful, with no broken dishes or glasses.

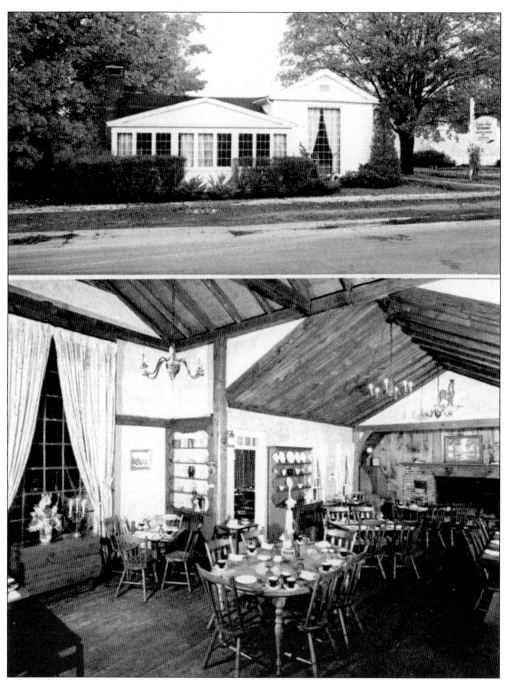

The Quaker Tea Room restaurant, on East Quaker Road, was a favorite for many years. Known for its charm and good food, the original house was constructed by Quaker Randal Baker, brother of Obadiah Baker (of Baker homestead), in the early 1800s. In the later years of its existence, the restaurant's name was changed to the Blue Fox and the owners endeavored to attract a younger crowd rather than the suburban gentry. Nuisance complaints were numerous until the building burned in 1973. On the site today is a contemporary office building, next to Brookins' Green patio homes.

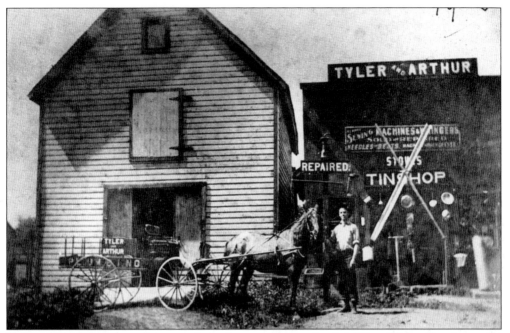

Tyler and Arthur's original store and tin shop, on the north side of East Quaker Road near the Four Corners, is seen in this 1908 photograph. W.G. Arthur Sr. purchased the original tinsmithing business and building from Maj. Thomas W. Tyler in 1908 and soon decided to move the business to the south side of West Quaker Road near the Four Corners.

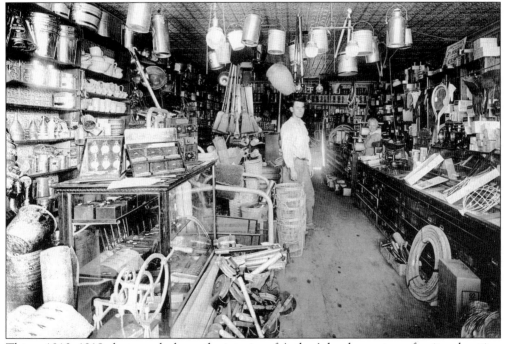

This *c.* 1910–1918 photograph shows the interior of Arthur's hardware store after its relocation to West Quaker Road. W.G. Arthur Sr. is standing in the aisle. His mother, Edna Arthur, is barely visible among the displays to the right.

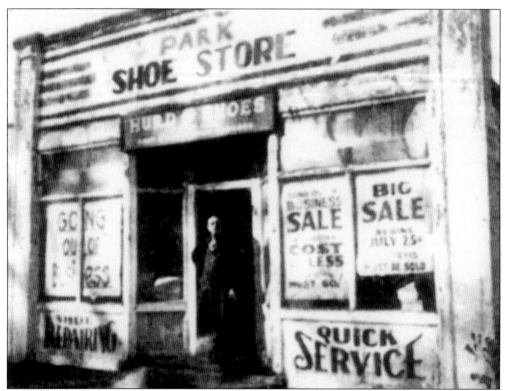

In 1958, the Park Shoe Store on South Buffalo Street was razed to make way for Arthur's present parking lot. The building originally was located just north of the Nativity rectory (now the Yield House Gift Shop), where it housed a bakery and then a general store. It was moved to the site of the present Arthur's furniture store, where the general store continued. It was then moved again, to this site, where it housed an upholstery shop and then a feed store. In 1928, Stanley Brzozowski opened a shoemaker shop in the structure. He operated this shop until 1959, when he retired to Florida. The picture above was taken shortly before the building was demolished. Below is Stanley at work in the shop. His son became an Orchard Park police officer.

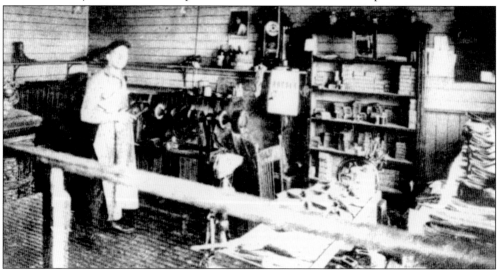

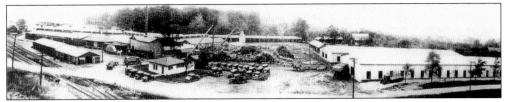

Acme Veneer, on Thorn Avenue, is shown above in the mid-1920s and is shown below in the 1940s. Although the corporate name of this business was Acme Veneer, it was unofficially known as the Basket Factory. Supplies were brought in by the railroad, which is shown on the left of the image above. Logs lying adjacent to the building were brought from the Boston Hills south of Orchard Park. Colon Dudley, Mason Holmwood, and Carlton Hambleton were the founders and operators of this early industry in Orchard Park.

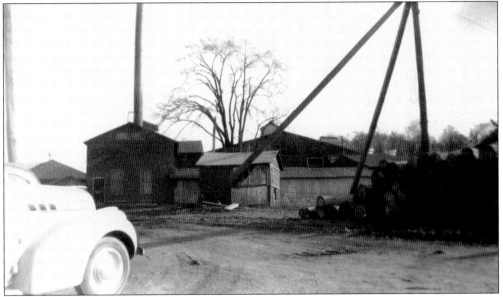

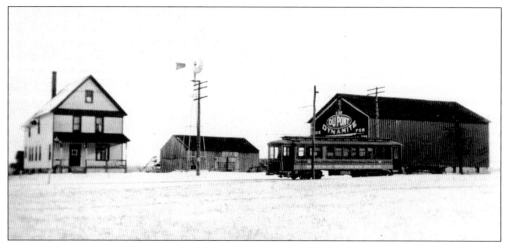

Benzinger Farm was on Abbott Road. Dynamite used in blasting stumps to clear land was stored here. Note the sign reading "Dupont Dynamite Co." Ralph Wilson Stadium, home of the Buffalo Bills of the National Football League, now occupies the site.

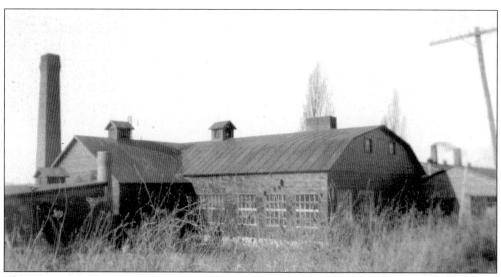

The Pottery Plant, now gone, was on Abbott Road roughly straddling the boundary between Orchard Park and Boston. Clay flowerpots were fabricated and fired in this facility. The location coincides with that of a brickyard established prior to 1821 by Ebenezer Pierce and later operated by his sons Pardon and Jeremiah Pierce.

Agriculture, the primary occupation of the community's pioneer settlers, is still an important occupation in Orchard Park. Hefty draft horses were the common source of farm power.

Three horses on a treadmill did the work of many men. This 1903 photograph, which is from a scrapbook of Clara and Bernard Benning, probably shows the Benning farm.

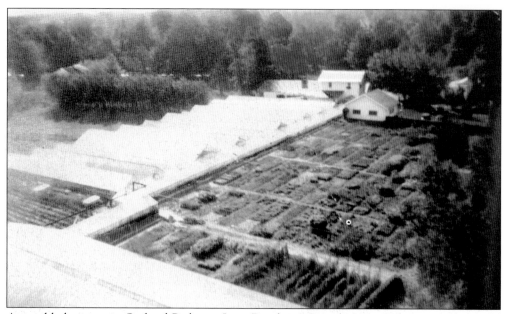

A notable business in Orchard Park was Jerry Brookins' Greenhouses. A devotee of beautiful flowers, young Jerry Brookins (1864–1934) purchased an acre of land on the north side of East Quaker Road in March 1889, and by 1897, he had built 19,000 square feet of greenhouses. The houses at the top of this 1937 photograph face East Quaker Road.

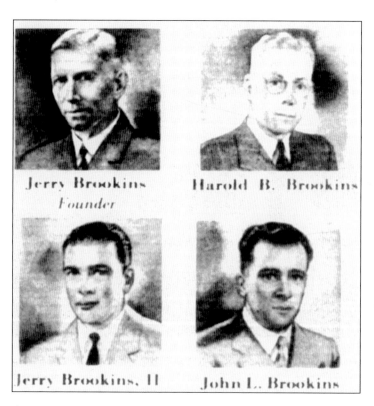

Jerry Brookins
Founder

Harold B. Brookins

Jerry Brookins, II

John L. Brookins

Brookins' market did business mainly locally and in Buffalo. Brookins' sold vegetable crops as well as flowers. Jerry Brookins's son Harold Briggs Brookins (1895–1995) entered the business after an internship with the Department of Agriculture in Washington, D.C. In 1946, after military service in World War II, Harold Brookins's sons John L. Brookins and Jerry Brookins II joined their father, becoming the third generation in the business.

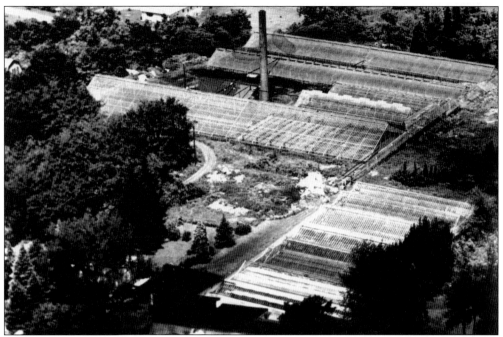

As the business expanded, Brookins' added more land and state-of-the-art greenhouses in 1914, 1920, 1926, and 1928. This 1960 aerial view of the greenhouses shows the full extent of the enterprise, with the original block of greenhouses in the lower right. Note the heating plant with its tall smokestack. There were nearly two acres under glass on over six acres of land. East Quaker Road would traverse across the bottom of this picture.

As originally constructed, Jerry Brookins' Greenhouses had no entrance along East Quaker Road. The pictured entrance was added sometime after 1900 and subsequently removed for the erection of a two-story office building in 1920. In 1946, a similar entrance was again placed off East Quaker Road. The acreage is the site of today's Brookins' Green patio homes.

Originally owned by Harry Yates, the Buffalo Brick Corporation, or "Brick Factory," was on Ellicott Road, adjacent to the Baltimore & Ohio Railroad (formerly the Buffalo, Rochester & Pittsburgh Railway, of which Harry Yates's father was president). Clay was dug from the earth near the plant. It was said that the company used improved methods of making bricks that did not take as long as the older methods. Some 45 men were employed at the Buffalo Brick Corporation.

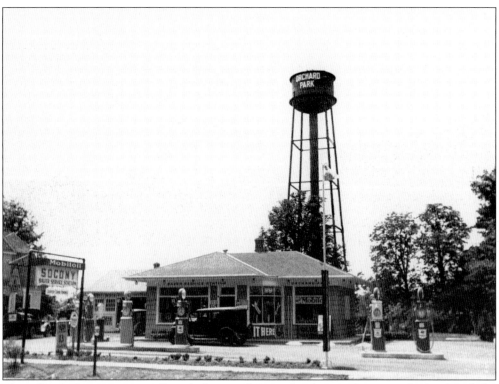

The village's first gas station, Bauer's Service Station, has been a fixture in Orchard Park for almost as long as the water tower. Joe Bauer's first station, basically for tire repair, had been built on Ellicott Road, east of South Freeman Road, in 1921. It was a secondary endeavor for Bauer, as he was also employed by Standard Oil. In 1926, he built the pictured station on the present South Buffalo Road site.

Four
CHURCHES

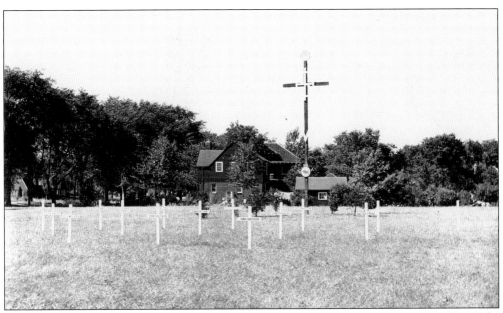

A simple memorial park was placed on the site of the present Nativity of Our Lord Catholic Church during World War II to memorialize local soldiers lost in the war. The names on the victory crosses are Alfred W. Walker, Robert M. McMurray, Joseph A. Miller, Irwin G. Saville, Brondo A. Capriotto, Robert W. Burdick, Raymond V. Larkin, Donald R. Link, Paul M. Nordblum, Gerald G. Haag, Donald I. Ogilvie, George M. Pabst, Ivan Davidson, Walter Coons, and Harvey M. Alman. The gold star mothers, reminded of their loss each time they passed the site, prevailed upon the parish to dismantle the memorial.

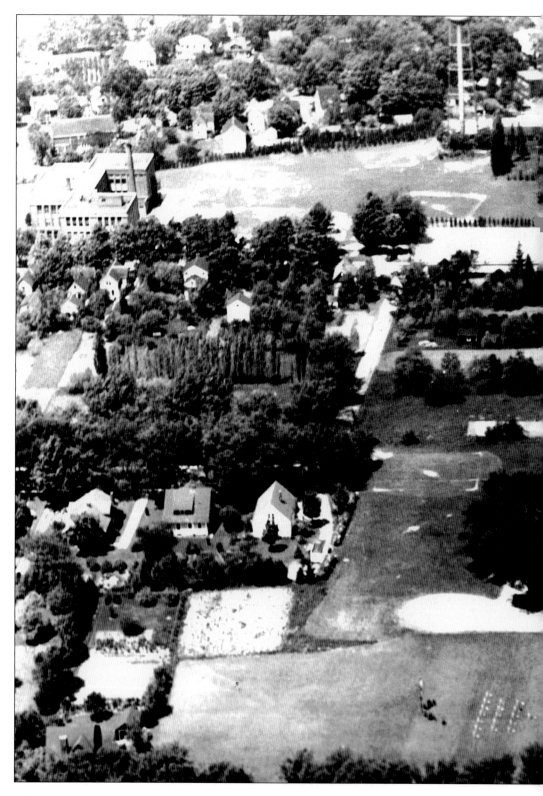

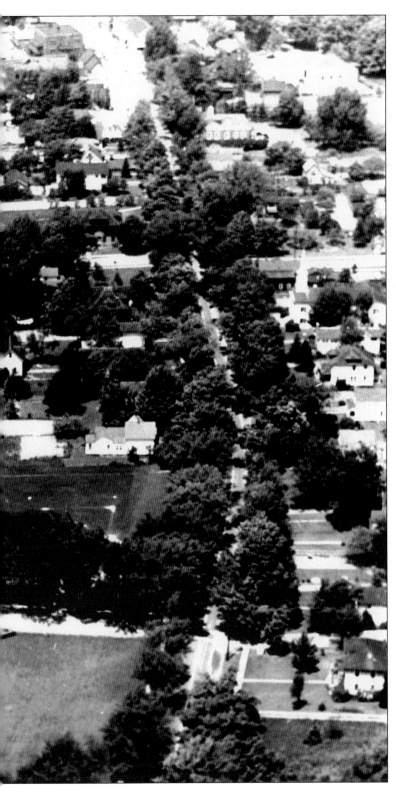

This aerial view was photographed c. 1945. In the upper left can be seen the 1914 Lincoln School, which served all grades of the district, augmented by small district schoolhouses that were still in use. Note the athletic field behind the school, now the site of the post office and fire station. The water tower has long been an adornment of Orchard Park. The Four Corners can be seen near the upper right. The Nativity of Our Lord Catholic Church and school building is lost in the trees in the foreground, but the World War II memorial park can be seen in the immediate foreground, later the site of the 1950 church.

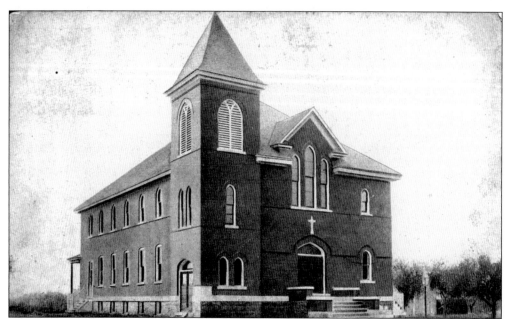

The first Mass of newly organized Nativity of Our Lord Catholic parish took place on New Year's Day 1908 in Lemuel Cook's funeral home, where the trappings of the funerary business were covered and folding chairs set up. This location served as the church until the new building was completed in 1909. The church occupied the second floor, while the first floor contained living quarters for two nuns and two classrooms, each of which held four grades. Later, the basement also held classrooms. In 1958, a large separate school was built, and in 1991, this original building was demolished to make way for a new parish center. Postmarked January 1913, the aerial postcard view of the church and school (below) shows no less than six gas wells in the vicinity.

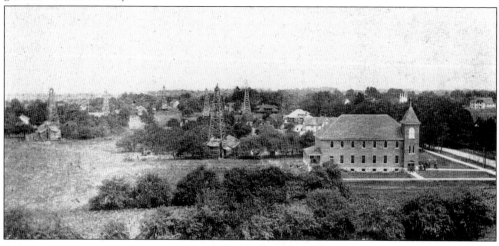

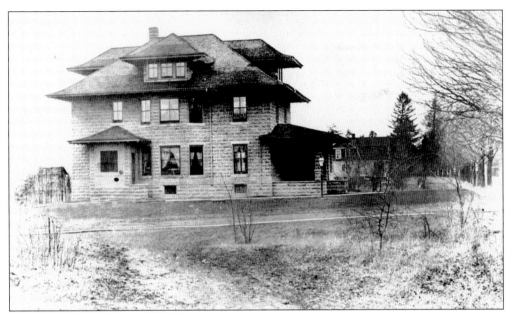

Shown c. 1909 is the first rectory for the Nativity of Our Lord Catholic Church, a concrete-block Sears catalogue home built on the northwest corner of South Buffalo Road and School Street. It served as the rectory until 1962. The building, without the front porch, still stands.

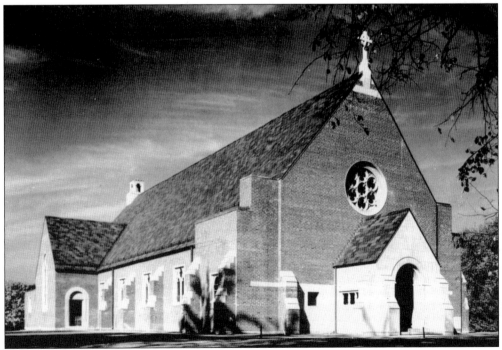

The new Nativity of Our Lord Catholic Church was built on land donated by Harry Yates on the condition that the church was to be void of entrance stairs in order to accommodate his wife, Mary "Mamie" (Duffy) Yates. The church was completed in 1950. The façade changed when the entrance was enlarged in 1993.

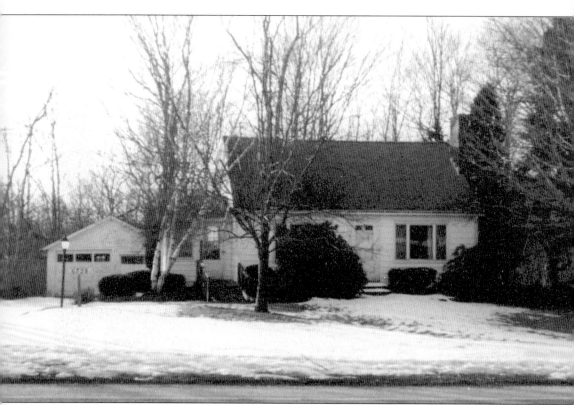

The First Methodist Episcopal Church was located on Chestnut Ridge Road immediately south of the Chestnut Ridge Road Cemetery. An 1853 deed indicates that a meetinghouse was located here prior to that time. Horse and carriage sheds were located behind the church. Used as a church into the late 1920s or early 1930s, the deteriorated building was sold in 1942 to Joseph and Lucile Almendinger, who removed what was left of the crumbling steeple, rebuilt the walls and roof (redirecting the roof line), dug a basement, and converted it into the comfortable country home pictured here.

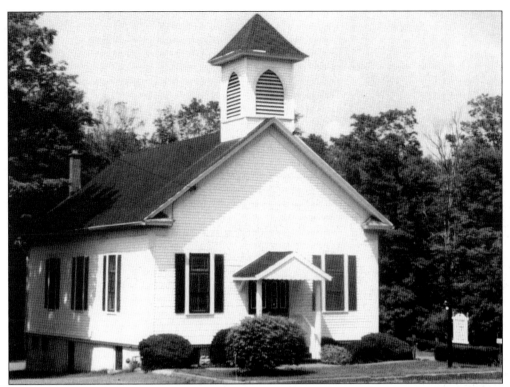

A small church known as Emmanuel Evangelical United Brethren Church was constructed on this site at Ellicott and Cole Roads in 1869. The church was built to serve members of the growing German community in this sector of the township. It was razed in 1910, and the present church (shown) was erected with a capacity for 125 people. In 1963, the old parsonage was sold and a modern brick ranch home was built to replace it. The church is known today as Emmanuel United Methodist Church.

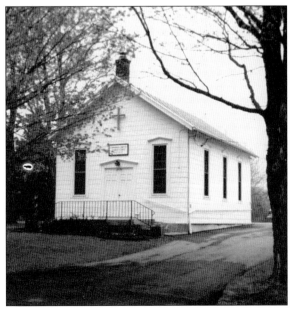

In November 1877, the trustees of the Evangelick Reformed Emanuel Church of East Hamburgh, Peter Schueler and Louis Hilliger, purchased 1.5 acres of land on the south side of Powers Road near Scherff Road from Adam and Maria Gernold for $50. The purchase was "for the purpose of building a church thereon, and for a burying ground." The congregation constructed this little church and began using its cemetery. Services were held in German into the 1930s. Today, this quaint church has a small but active congregation and is known as Emmanuel United Church of Christ.

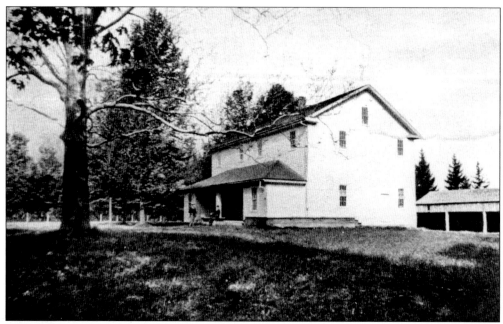

The above picture of Orchard Park's Quaker meetinghouse dates from c. 1895. The below photograph was taken in May 1909. Completed in the early 1820s, the meetinghouse was built on a three-acre plot sold to the Society of Friends in 1817 by Aldrich Arnold for $115. Subsequent land transactions resulted in today's land configuration. The venerable building is constructed of hand-hewn beams secured by wooden pegs and enclosed by wide boards, or planks, covered with clapboards. Note the horse and carriage shed behind the building. This meetinghouse replaced the pioneers' log-house-turned-meetinghouse, once located on a half-acre on the northeast corner of the Four Corners, that was sold to the Friends in 1811 by David Eddy.

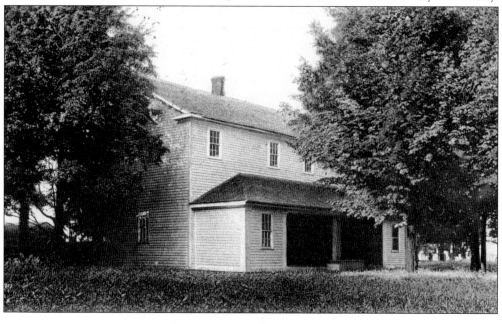

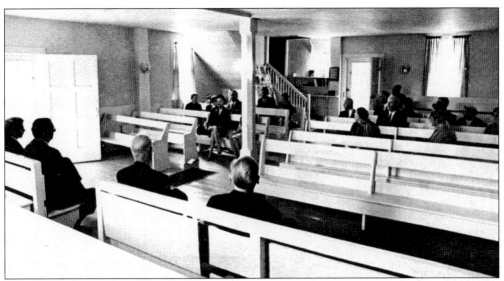

Inside, the meetinghouse was divided into two equal rooms separated by a movable partition to accommodate joint meetings for worship for men and women but separate meetings for business. A balcony was built across the second floor. The benches were hard and straight. The elders occupied the few raised benches facing the general congregation. The interior of one side (pictured here) has been maintained for worship to this day, little changed except for installation of a ceiling that occludes the balcony.

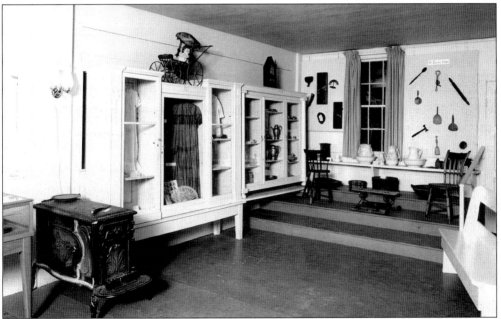

The second room in the meetinghouse is equal in size to the room presently used for worship. For many years, the building was used as a museum by the Orchard Park Historical Society. By the early to mid-1900s, the Friends congregation had declined in number, meetings were down to just one a year (the first Sunday in May), and the meetinghouse was sadly neglected. A renewed interest in the Society of Friends, plus community interest in this historic architectural gem, fostered restoration and preservation of the building.

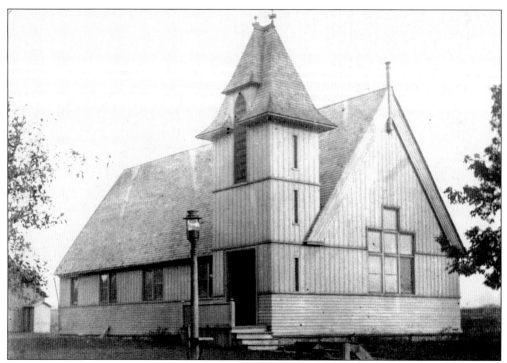

In 1891, a small group of Episcopalians organized a mission church, Saint Mark's. A lot on the east side of Potter Avenue just south of East Quaker Street was purchased for a church building in 1892. On Easter Sunday 1893, this new wooden church was dedicated. Soon after 1900, a guildhall, containing a meeting hall and kitchen, was built in back of the church. In this c. 1925 photograph, the gas lamp is noticeable and the church is resting on jacks. The building remained on jacks for three years while the small congregation had many heated discussions as to where and when it should be moved.

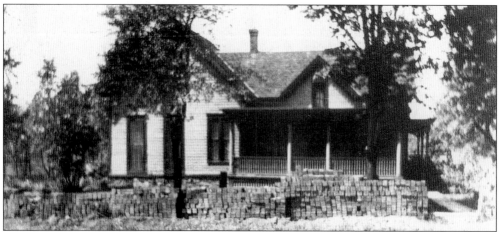

Solon Willey bought and gave this house to St. Mark's for use as a rectory, allowing the congregation to hire its first resident minister in 1900. Piled in the foreground are the bricks that were about to become East Quaker's roadbed. These bricks were removed in the summer of 2002, when the road was reconstructed. The house still stands at 6630 East Quaker Road on the north side of the road. It is the second door east of Sunset Lane.

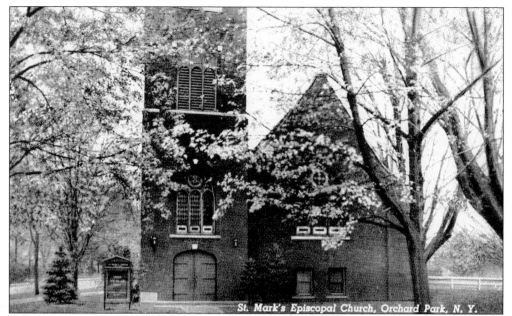

St. Mark's Episcopal Church, Orchard Park, N. Y.

St. Mark's Episcopal congregation purchased a lot at the southwest corner of East Quaker Road and Potter Avenue in 1924. In 1925, the church was moved across Potter Avenue to its present location, ending a difficult three-year period of indecision. The wooden structure and tower were then given a brick veneer. Note the church entrance located through doors in the tower. Subsequent alterations and enlargements in 1954, 1967, and 1991 have changed this façade and the overall size of St. Mark's Episcopal Church.

This building, on the south side of Ellicott Road, was originally the Second Methodist Episcopal Church, built shortly after July 1862, when trustees Ambrose Cole, Joseph C. Griffin, and Oliver C. Griffin took deed to the land. It became commonly known as the Ellicott Methodist Episcopal Church. After the congregation dwindled, the building was sold in 1915 and was subsequently converted into a comfortable home.

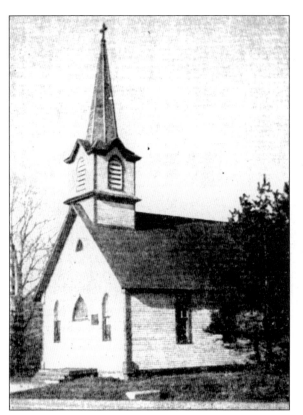

In 1906, a small group of Lutherans living in the Chestnut Ridge section south of the village came together for worship in the home of Herman Meyer located at the corner of Newton and Bunting Roads. The congregation formally organized in 1908 and was called St. John's. The church was built on the east side of Chestnut Ridge Road, south of the bridge that today connects the two sides of Chestnut Ridge Park. The church building also served as a Christian day school until 1913, when a one-room schoolhouse was built. Grades one through seven were taught by one teacher, usually the attending pastor. The school burned in 1914. Quickly rebuilt, it functioned until 1926. Today, all of the original buildings have been converted into private dwellings.

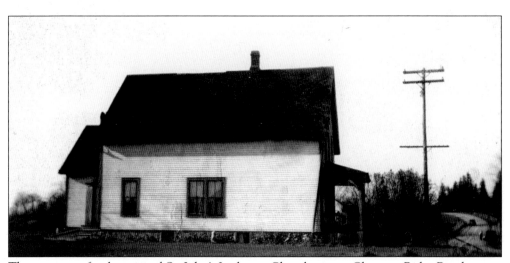

The parsonage for the original St. John's Lutheran Church was on Chestnut Ridge Road, across the road from the church. This photograph is dated April 1946.

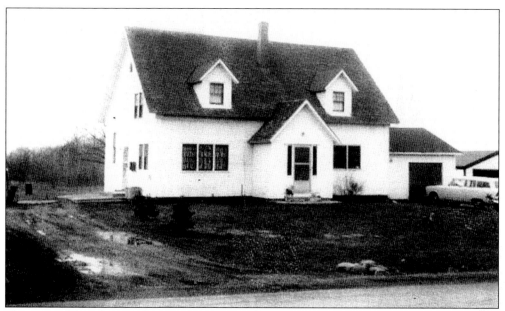

The original St. John's Lutheran Church was sold in 1948, moved across Chestnut Ridge Road, and converted into this residential duplex that still stands.

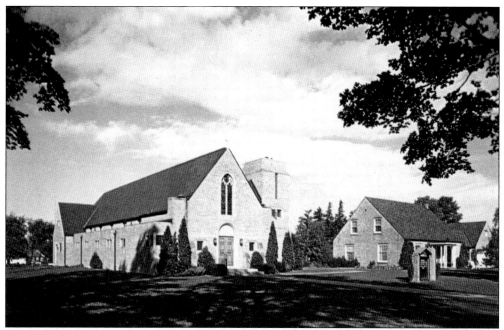

The land on the northwest corner of South Buffalo and Highland Roads was donated to the Lutherans by Harry Yates. Ground was broken for a new church in 1945. The new St. John's Lutheran Church became a reality in 1948. A new parsonage was built next door.

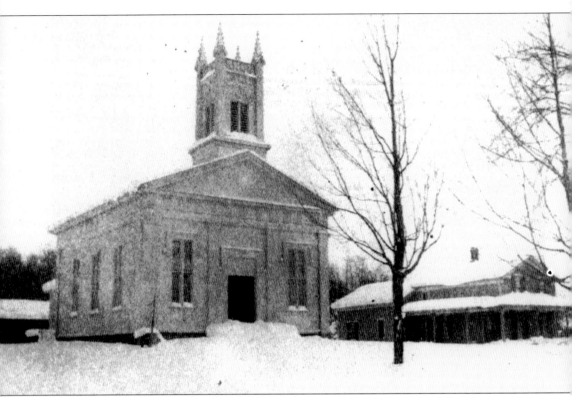

In June 1851, Allen Potter and his wife, Elizabeth, sold a portion of their land to the trustees of the First Congregational Church of Ellicott for $75. The trustees were Amos Chilcott, Orson Swift, Asa R. Trevett, Zebulon Ferris, and Archibald K. Huson (Hewson). This handsome Greek Revival church was built in 1852 on what is now South Buffalo Road. Carriage sheds, at the rear of the church, are evident on the left.

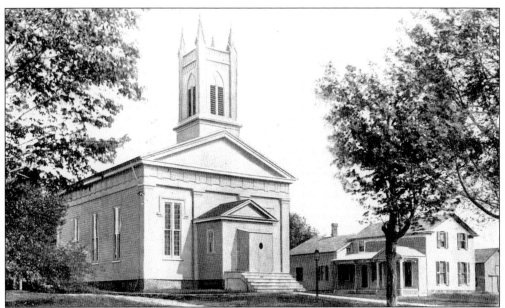

The First Congregational Church of Ellicott, subsequently reorganized in May 1853 as the First Free Congregational Church of East Hamburg, is pictured. The organizing members were Fred H. Long (deacon), Mrs. Fred Long, Archibald K. Hewson (treasurer), Sarah Hewson (the wife of Archibald), Henry Knapp (deacon), Hannah Knapp (the wife of Henry), Abagail Knapp (the mother of Henry), Gershom Knapp (the cousin of Henry), Putnam Ayer, Maria Ayer (the wife of Putnam), Chauncey Abbott (secretary), William Washburn, Hannah Washburn (the wife of William), Lucy Swift (the wife of Cushing), Julia Swift (the wife of Orson), and Polly Utley Lockwood (the wife of Philo). In 1859, the congregation voted unanimously to change the church's form of government from Congregational to Presbyterian. Notice the barn located to the right of the manse. The church now has an entrance vestibule.

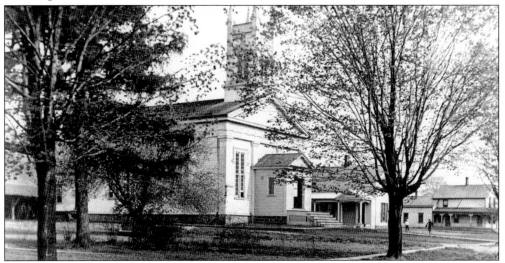

In the latter 1800s but prior to 1876, the congregation moved a large farmhouse from Freeman Road across the then open land to Buffalo Road. This house, visible in both this and the previous image, became the manse and is still next to the church. The barn next to the manse is now gone.

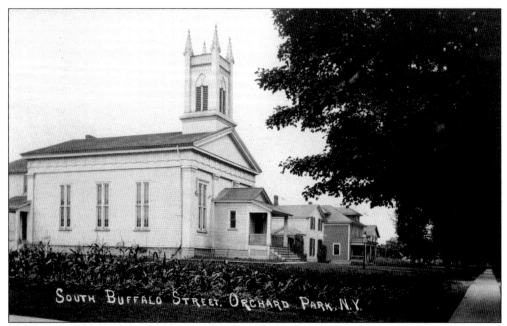

SOUTH BUFFALO STREET, ORCHARD PARK, N.Y.

In the top image, a house now appears where the barn used to be, a covered portico has been placed in front of the vestibule, and an addition has been built at the rear of the Presbyterian church. In the lower image, the addition is further defined, and aesthetic improvements include split shutters for the long windows.

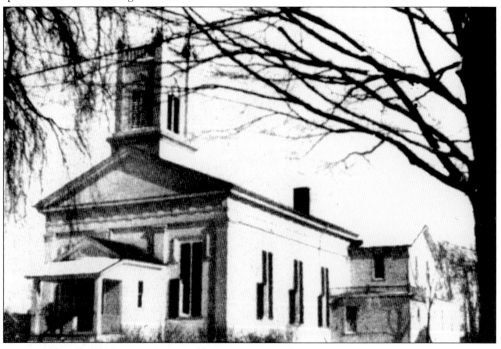

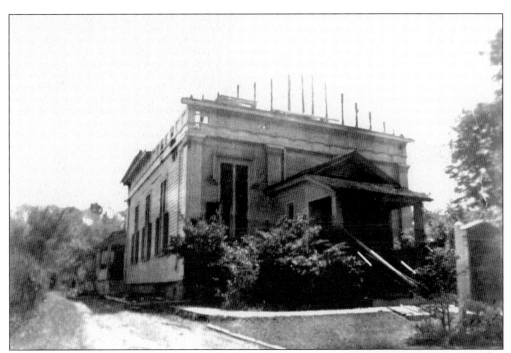

In 1938, a disastrous fire destroyed the first Presbyterian church. However, members did not let the lingering effects of the Great Depression hamper their determination. They set about planning and rebuilding almost immediately. Services were held in the Quaker meetinghouse while rebuilding took place.

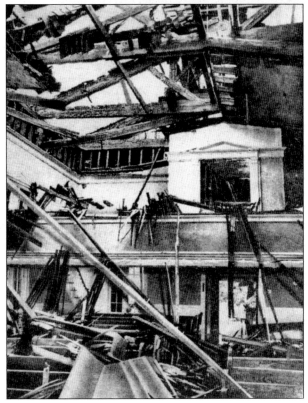

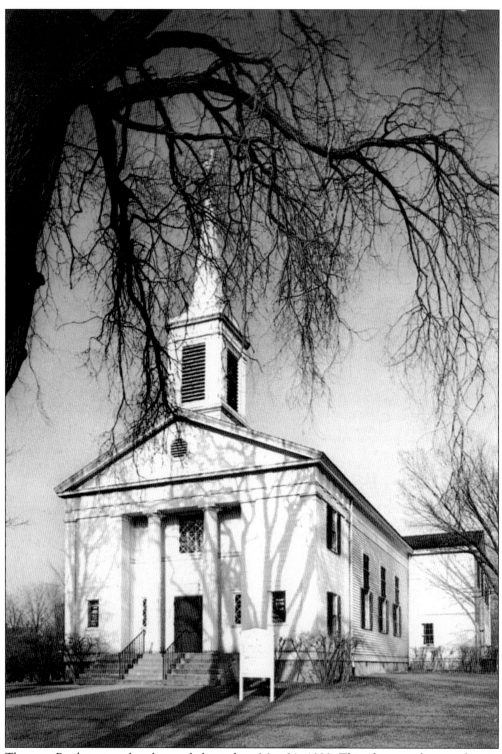

The new Presbyterian church was dedicated on May 21, 1939. This photograph was taken in May 1963.

Five

STREET SCENES

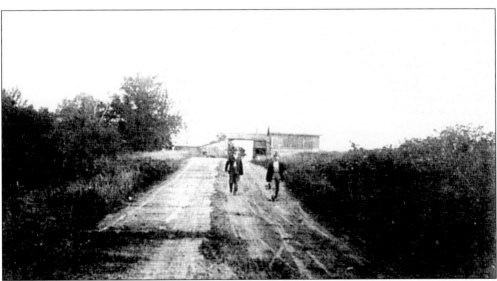

A few primary roads were developed into plank roads by local investors in the mid-1800s. They were free of ruts, mud, and dust and had bridges over streams, but travelers paid a toll to use them. This is the only known photograph of the tollgate (the arched structure in the distance) on what is now South Freeman Road, approaching what is now Ellicott Road. At that time, the road southeast from Deuel's Corners, known as the East Hamburg Turnpike, followed its course to Dennis Road. Dennis Road led to South Freeman and through the tollgate to become the Cattaraugus and Buffalo Plank Road (*c*. 1862), now Ellicott Road. The left side of the roadbed appears to be planked, and the right side is still dirt.

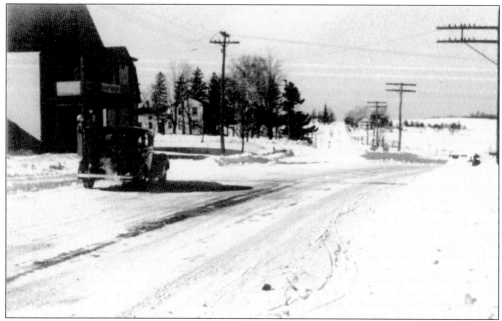

South Freeman Road used to enter the Cattaraugus and Buffalo Plank Road at about the point from which the photographer took this *c.* 1940 photograph, looking west on Ellicott Road. The intersection has been redesigned and Powers Road (center distance) is no longer continuous with Ellicott Road. Powers Road now ends at Scherff Road, which enters from the left in this view. Scherff Road is now continuous with South Freeman Road. Ellicott Road has a new course to the right. The car, apparently driving on the wrong side of Ellicott Road, is probably about to enter the gas station, now the home of Rix's County Store.

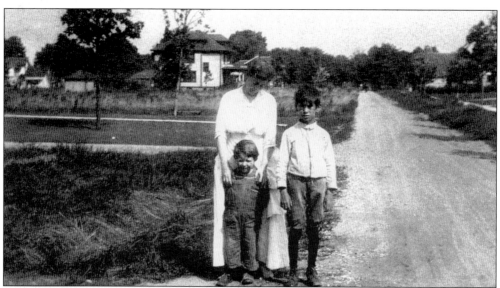

This view looks north from Clark Street toward Potter Avenue. Clara Briggs Abbott (1886–1978) poses for this picture with her son, Franklin, and young Mr. Bowers, a family friend, *c.* 1916. Her husband, Walter Davis Abbott (1876–1958), was commissioner of public works in Orchard Park.

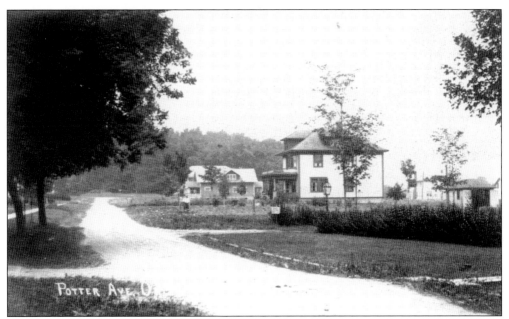

This *c.* 1920 view looks south from the west side of Potter Avenue, showing the other side of the two-story house that appears in the previous picture. That house is now on the corner of Canterbury Court.

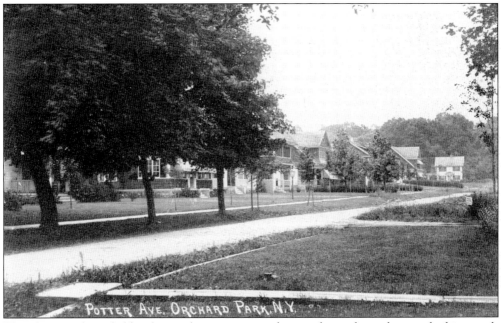

This photograph, probably taken at the same time as the one above, shows the view looking south from the east side of Potter Avenue. Note the plank sidewalk and carriage step in the foreground.

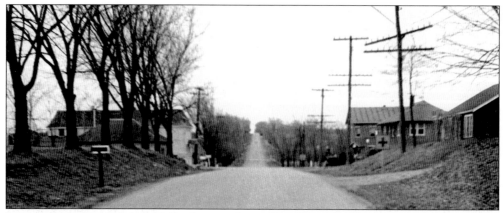

In the foreground of this 1941 photograph is Armor Road. The view looks toward the intersection of Buffalo Road. Jewett-Holmwood Road extends up the hill into the distance.

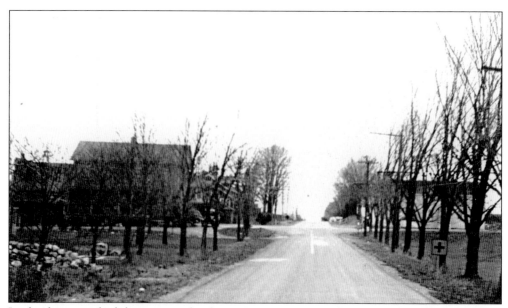

In the foreground of this image, also from 1941, is Jewett-Holmwood Road. The view looks toward the intersection of Buffalo Road, with Armor Road extending in the distance. On the left is the building formerly owned by the Rappl family, which now houses Ganer's. On the right, across Buffalo Road, is the former Eckl's Park Ridge Grill.

This 1941 photograph shows Buffalo-Chestnut Ridge Road in the foreground, with the view looking toward the intersections of Armor and Jewett-Holmwood Roads and Ellicott Road. On the hill in the right distance is the caretaker's house on the Orchard Park Country Club grounds. The building was later demolished for parking space.

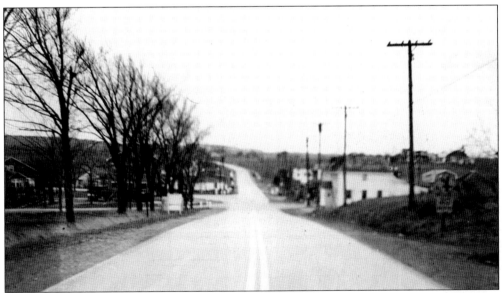

In the foreground of this photograph, taken in 1941, is the intersection of Jewett-Holmwood and Armor Roads as seen from Buffalo Road. Ellicott Road branches to the left. Buffalo Road becomes Chestnut Ridge Road, which extends into the distance. Eckl's Park Ridge Grill is on the corner to the immediate right.

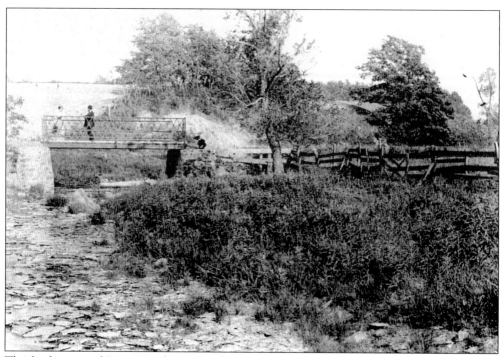

This bridge carried Duerr Road over Smokes Creek *c*. 1896.

Shown here are houses along the west side of Lincoln Street on July 16, 1929. Lincoln Street was then a dirt road.

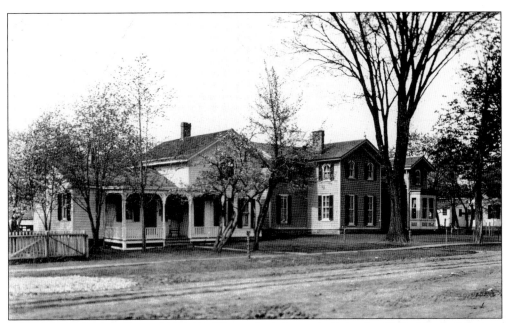

The home of Carlton Briggs (1858–1935), on the left, was built in the 1840s. The building on the right was a home and office to Dr. Philip Dorland (1837–1866), Dr. L.F. Boies, and, later, Dr. Howard L. Hunt (1863–1928). This c. 1900 photograph shows the north side of East Quaker Street. A brick structure was built on the site of the Briggs house, and this became the central telephone exchange, then the community library, and most recently the town annex offices. It is immediately east of the Four Corners. The Dorland-Hunt building (which appears to be two buildings divided by a tree, but is actually a single building) was moved in 1986 to accommodate today's commercial building at 6532 East Quaker Road. It now stands on the north side of West Quaker Road.

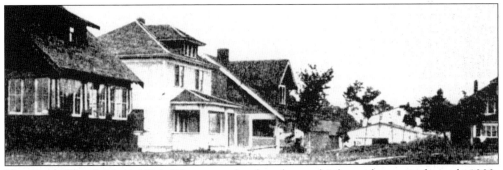

The farm of Frank M. and Eola Thorn was developed as multiple residences in the early 1900s and was initially called Thorn Heights, a name that failed to endure. Shown is Harvard Place, located within that development.

These views along West Quaker Road look down the hill toward Lincoln.

These views also show West Quaker Road. John Townsend's house is on the right, on the south side of the road.

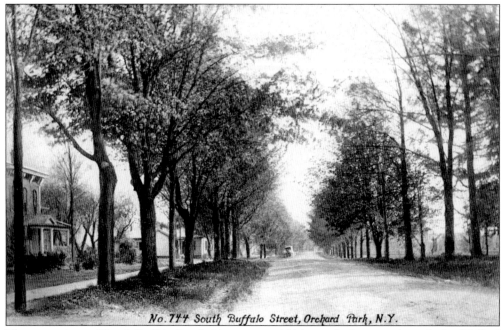

No. 744 South Buffalo Street, Orchard Park, N.Y.

These are views of South Buffalo Road. Above is a *c.* 1911 view looking south, with the Clifford Hawkins house on the left. The building was demolished in 1940 for the construction of a post office, which now houses the municipal board and a courtroom. The *c.* 1912 view below looks north from the road. The Nativity of Our Lord rectory is on the left. Today, this is a gift shop on the corner of School Street. A.K. Hoag published these picture postcards.

Shown is another scene along tree-lined South Buffalo Street.

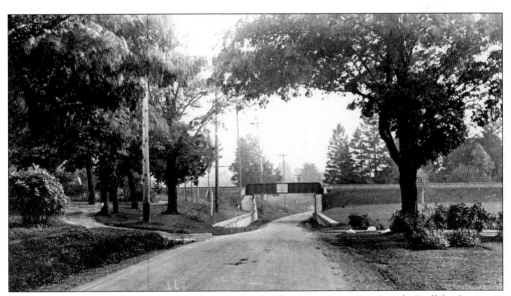

The Buffalo, Rochester & Pittsburgh Railway Bridge, running over South Buffalo Street, is shown in this c. 1915 view looking south. The road was straightened and widened to four lanes between 1966 and 1968, and this bridge was replaced.

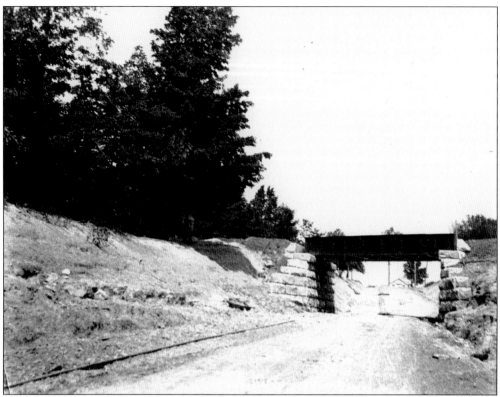

This Windom neighborhood railroad bridge runs over Abbott Road.

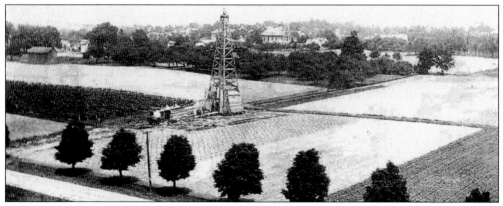

This scene shows gas wells, which represented a former industry in Orchard Park. In 1912, there was a gas well boom in the township. In addition to the obvious well in the foreground, at least two others can be seen in the background.

Six
NOTABLE EARLY HOMESTEADS

Quaker Obadiah Baker (1773–1831), an 1807 pioneer settler of the community, built a log cabin as the first house for his wife, Anna Wheeler, (1774–1857) and family. Located on the north side of East Quaker Road, somewhere between the present Baker Road and Smokes Creek, it served as his residence and also as the setting for the first meetings of the fledgling Quaker community beginning in 1807. This *c.* 1892 photograph shows the plank cabin Baker built *c.* 1813. It was his second local home and is now the original part of the larger house. The cabin (right foreground) is the one-and-a-half-story extension. It is still in use, as the kitchen. Descendants relate that the loft of the cabin was used as a station in the Underground Railroad, where runaway slaves were sheltered and fed on their dangerous journey north to Canada and freedom. Obadiah Baker fathered 12 children.

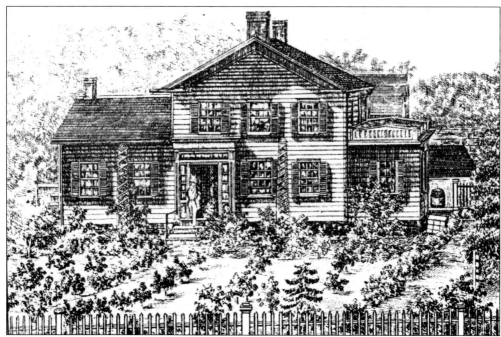

Obadiah Baker's youngest son, Benjamin B. Baker, continued to reside in the cabin, and he accomplished the additions that converted the cabin into a large house. He began this work in 1840, hand hewing all of the beams and planks. This c. 1855 sketch of the front of the house shows the completed first phase of this conversion: the two-story central portion flanked by single-story wings. The first photograph of the house, on page 85, shows that by c. 1892, the right wing had been extended and both wings raised to two stories.

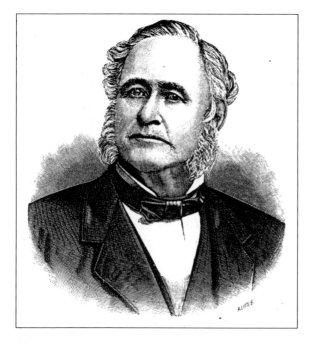

Pictured is Benjamin B. Baker (1817–1905), who finished the initial additions in 1842 and wed Anna Freeman (1821–1887), a daughter of Elisha Freeman, in the same year. They graced the Baker homestead with 10 daughters and a son. Baker served as town supervisor of East Hamburg and was a charter member of the East Hamburg Historical and Agricultural Society, which became the Erie County Fair. The refuge station for the Underground Railroad was provided during his residency in the house. The farm contained 143 acres.

Two older pictures of the Baker homestead show the primary dwelling after alterations (left) and another Baker home (right). Both homes faced East Quaker Road. The second home was built by Benjamin Baker's only son, Elisha Freeman Baker. Modern Baker Road was a dirt lane separating the houses. A large barn can be seen behind the primary house. During his father's widowhood, E. Freeman Baker moved his family into the primary house, and the second residence was subsequently sold out of the family.

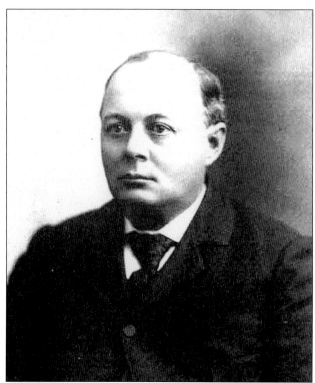

Pictured is E. Freeman Baker (1851–1922). In 1878, he married Julia Ada Potter (1853–1921), daughter of Gilbert and Phebe Potter. They raised three sons on the homestead, including Benjamin G. Baker (1879–1946), who subsequently raised his family in the primary house. It was Benjamin G. Baker who modernized the house, bringing in plumbing and electricity.

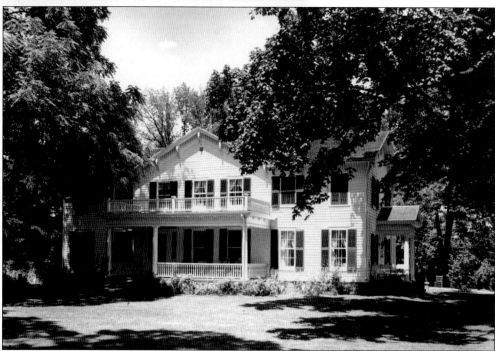

A more recent picture of the primary house on the Baker homestead shows both wings raised to two stories and a large front porch, which conceals the handsome window detailing over the front door. The house is no longer in the Baker family.

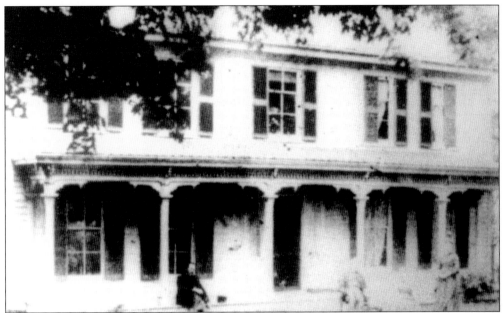

Samuel Abbott (1779–1846) and his wife, Sophia (Brown) Abbott (*c.* 1788–1838), arrived in the community in 1807 with his brother Seth Abbott (1769–1831) and his family. The Abbotts invested in large tracts of land. Samuel was a farmer and surveyor, who surveyed all of the principal early roads in Erie County and, in 1812, was the first overseer of highways and fence viewer for District 10, East Hamburg. It is written that the brothers were "highly respected, conspicuous, and influential as committee members during the War of 1812." Samuel Abbott was the second supervisor of Hamburg in 1813, but soon thereafter moved to the town of Boston where, at the first Boston town meeting in 1818, he was elected first supervisor of Boston. He returned to East Hamburg and built this home on East Quaker Road *c.* 1825 in front of the log house he had originally constructed about 10 years earlier. During the War of 1812, fearful that the British would continue their march of destruction past Buffalo, the Abbott family members placed their silverware and kitchen utensils in a well located a few feet from the side porch. Remnants of this well could be seen well into the 20th century.

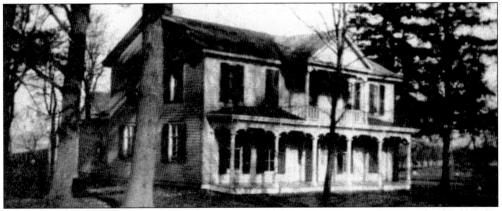

A second-story covered porch with a railing was later added above the center portion of the first-floor porch. After Samuel Abbott died, his son Chauncey Abbott (1816–1890); his son's wife, Charlotte (Brown) Abbott (1822–1894); and their family returned from Buffalo to the homestead to take up residence in 1851.

Pictured are Chauncey Abbott's son Franklin Brown Abbott (1843–1924) and his son's wife, Lucelia S. (Davis) Abbott (1850–1928). Franklin Abbott was a captain of a company of militia during the Civil War. Upon returning to the homestead *c.* 1870 to raise a family, he became active in inducing the railroad to come through the community and in bringing about the construction of the old Union School, which succeeded the Friends Academy.

The 20th century saw many changes to the old Abbott homestead, including two paved streets where farm paths had been: Chauncey Lane and Franklin Street, both named for homesteaders. This view of the house, as seen from Chauncey Lane, is now framed by adjacent homes, including the former sanitarium (right).

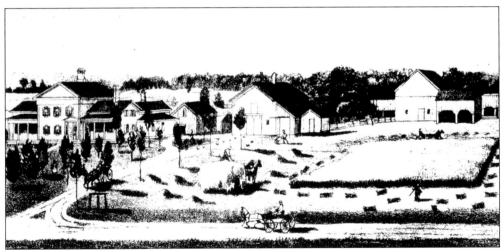

David Pearson White (c. 1788–1868) and his wife, Betsey (Platt) White (1787–1867), came to this community c. 1818 and later began buying acreage. Ultimately, White owned large tracts of land from East Quaker Road to south of Jewett-Holmwood Road. Sometime in the 1830s, he built his home on East Quaker Road, east of present Quaker Lake Terrace. Sketched here is the homestead as it appeared c. 1880, when it was owned by John Webster White, David Pearson White's grandson. Notice the balanced, columned wings on either side of the house.

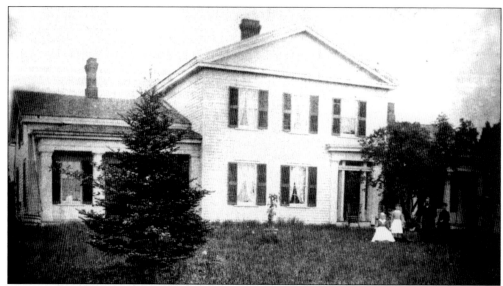

This was the appearance of the White residence before it underwent dramatic changes, alterations perhaps compelled by years of expanding family. The White homestead became a three-generation residence after the marriage of David Pearson White's youngest son, Albert Allen White (1813–1875), to Mary A. Webster (1815–1894). Albert White's son John Webster White (1843–1891) owned it next. Note the roofline with Greek Revival pediment. David Pearson White leased a one-acre plot on East Quaker Road in the northwest corner of his lands "for schoolhouse purposes." The lease was maintained until the centralization of schools in Orchard Park in the 1940s. The school was known as the Little Red Schoolhouse, or District No. 2.

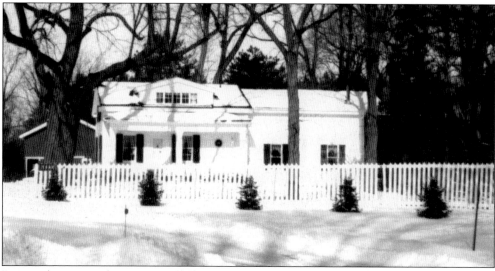

During alterations, the east wing (left) of the White homestead was moved across East Quaker Road where, with an addition, it became an attractive residence.

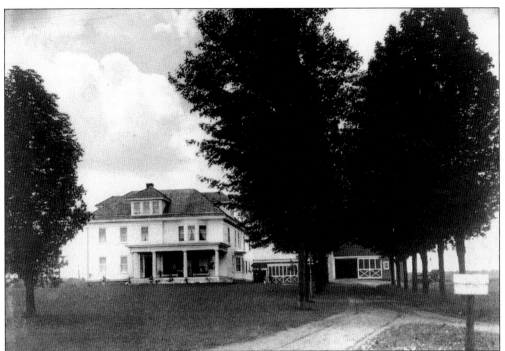

After the east wing of the original White house was separated and moved across East Quaker Road, a second story was built above the west wing, the porch was altered, and the roof was totally rebuilt, allowing living space with dormers on the third floor. In 1901, farmer and soon-to-be town supervisor Frank F. Holmwood (1859–1927) and his wife, Metta V. (Baker) Holmwood (1859–1938), purchased the homestead of 164 acres and named it Woodholm. At the time the above photograph was taken, the homestead was owned by Harry Yates, who had purchased it as he expanded his landholdings. The superintendent of Yates Farms, Ed Wado, lived in the house. The photograph below was taken in the 1960s, when the home was owned by Ward and Mary Abbott.

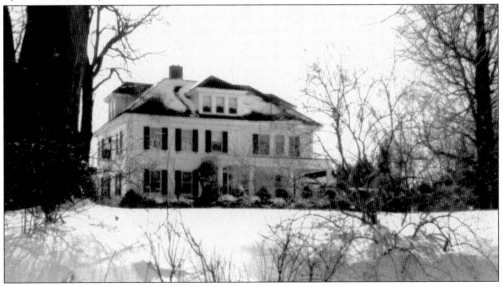

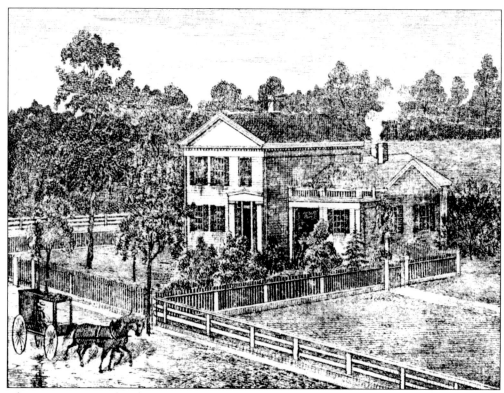

Above is a c. 1855 sketch of the Allen Potter home. The later photograph below was taken after the wing was extended and raised to include a second story. The house, built sometime before 1850, is now the Brown Funeral Home on East Quaker Road.

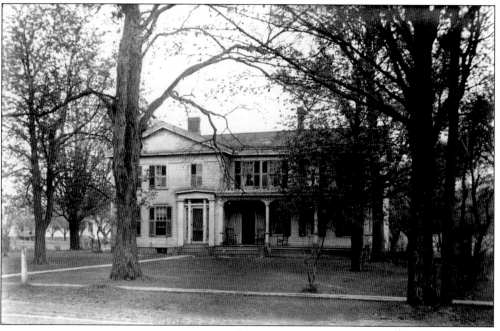

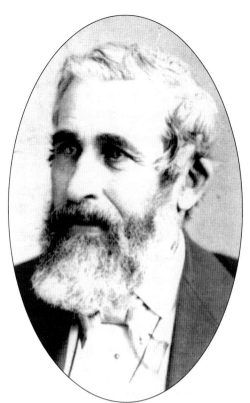

Allen Potter (1807–1877) was a son of pioneers Joshua and Judith (Palmer) Potter, one of the first babies of European descent to be born in the community. In 1830, his father set him up in business as owner and landlord of the village tavern, at the Four Corners, which later became the East Hamburg Hotel and much later became the Orchard Downs. Allen Potter married Elizabeth Thurber (1810–1878) and became an entrepreneur of unrivaled proportions in East Hamburg, opening mercantile stores and a blacksmith shop. He was also a principal in the construction of three area plank roads. He served as postmaster and justice of the peace, was a member of the board of supervisors and the state constitutional convention in 1866, and was a commissioner of the city and county at the time the present county building was constructed. Allen Potter was also president of the East Hamburg Friends Institute, a trustee of the Buffalo Normal School, and a director of the Manufacturers and Traders Trust Company. For several years prior to his death, he was a director of the Buffalo Courier Company, forerunner of the *Buffalo Courier-Express* newspaper publishers. It has been said that the Fitzgerald family, who then lived in Buffalo, boarded with the Potters during the summer to enjoy the fresh, healthful climate for which the community was known. With them was their young son, F. Scott Fitzgerald, who later wrote *The Great Gatsby* and other classics. The Potters raised two daughters to adulthood.

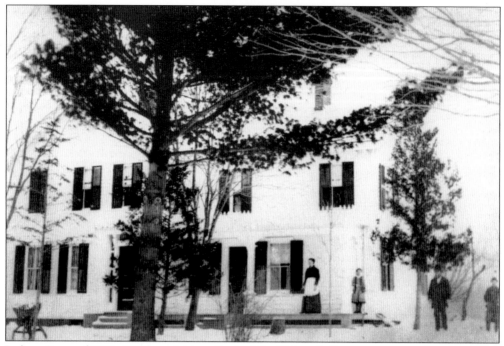

Joshua Potter (1781–1860) and his wife, Judith (Palmer) Potter, came to this area from Vermont in 1806 and homesteaded on a farm of 138 acres on West Quaker Road. It is possible that the original farmhouse built by Potter is subsumed within the pictured house, but his son Gilbert Potter (near right) was probably the builder. The others in this photograph are unidentified friends of the family.

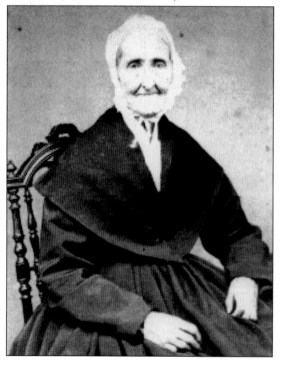

No photograph of Joshua Potter has survived, but his wife, Judith Palmer Potter (1786–1873), posed for this image dressed in her Quaker bonnet and shawl. It was said that she once shot a bear that was menacingly close to the house. She was the mother of two sons, Allen and Gilbert, and five daughters, Hannah (who married Isaac Sisson), Lovina, Emma (who married Walter Wood), Diana (who married Edmund P. Palmer), and Ruth (who married Gilbert Knapp).

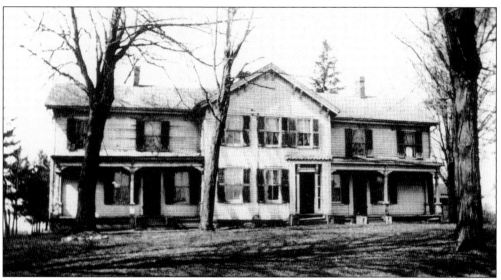

This photograph of Potter homestead probably dates to the tenure of Gilbert Potter, after the west wing was added. This is now the Quinn Funeral Home.

A handsome carriage horse was desirable for jaunts into town or to church. Joshua Potter's grandson Gardner B. Potter, the only son of Gilbert Potter, is standing in the carriage. The children of Gardner Potter's only child, Fannie Ella (Potter) Trevett, were the fourth generation to enjoy the homestead. The barn still stands behind the Quinn Funeral Home.

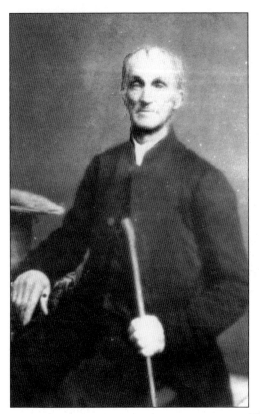

Bachelor Elisha Freeman (1794–1865) arrived in Orchard Park in 1816 from his home in the Washington County community of Easton. He was the son of Revolutionary War patriot soldier Baptist Stephen Freeman and his wife, Quaker Anna (Baker) Freeman. Freeman first married, in 1820, Abigail Smith (1796–1825), sister of pioneer Dr. Elisha Fitch Smith, and purchased two parcels of land. In February 1821, Freeman purchased a third parcel, 41 acres on the west side of what is now Freeman Road, adjoining present-day East Quaker Road, from Aldrich Arnold for $540. This land bordered the western edge of his original acreage, increased the farm to over 120 acres, and became the site of the still-standing Freeman homestead. Elisha, but not Abigail, joined in membership with the Quakers in 1821. Abigail died at the age of 28. In 1826, Freeman married Quaker Mary Varney (1797–1890) in a Quaker ceremony in the nearby Quaker meetinghouse, and both subsequently became prominent in the Hicksite Quaker community. Pictured are Elisha Freeman and his second wife, Mary, wearing her Quaker bonnet.

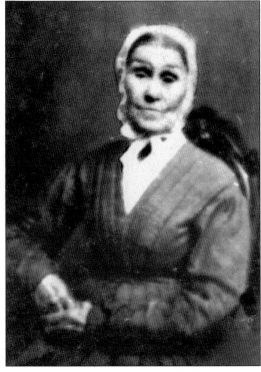

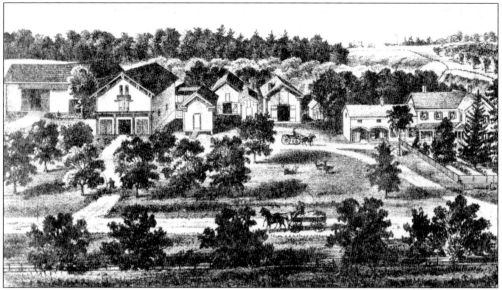

Elisha and Abigail Freeman had two daughters. Freeman and his second wife, Mary, had two more daughters and three sons. Of the sons, Amos (1827–1897) and Elias (1832–1910) lived to adulthood and worked the farm with their father. In 1865, the Freeman home, a plank house, was valued at $2,500, the second-most valued residence in East Hamburg. The farm was valued at $16,000. It is not known if remnants of the buildings, which were on Aldrich Arnold's farm at the time he sold it to Elisha Freeman in 1821, are embodied within the later buildings of the farm, as shown in the above 1880 sketch. It is known that Elisha and Mary Freeman ultimately owned a very large house of some 17 rooms on this site, ostensibly the result of family additions through assimilation of senior parents, birth of children, and later integration of their children's spouses and grandchildren.

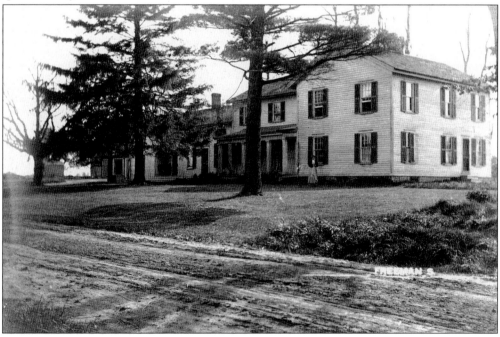

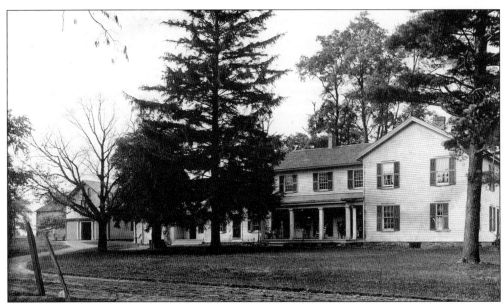

This photograph of the Freeman homestead is from a postcard dated August 1908. It is said that the Freemans welcomed many guests to their home for extended visits. Among them were Quakers attending local monthly or quarterly meetings and visiting Quaker ministers. Native Americans who traded in the area were readily welcomed into the warmth of the Freeman home, especially in inclement weather. Their home was known for miles around as one of the largest and most gracious in the region. Note that the sketch and photographs show a perpendicular wing on the right (north) side of the Freeman homestead. Today, the remodeled house has a flush front façade parallel to Freeman Road.

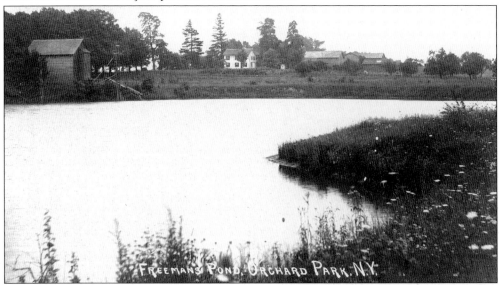

The following postcards bear 1908 and 1909 postmarks. The Freemans eventually owned a farm of over 200 acres, through which a branch of Smokes Creek passed. They dammed the creek, causing a pond to form from which they could cut ice in winter for refrigeration. The pond is still known as Freeman's Pond. Looking across the pond from near East Quaker Road, the icehouse is visible on the left. In the distance are the homestead and barns.

This is another view over Freeman's Pond, showing Freeman Road and the residence c. 1909. Ultimately, Amos Freeman and his family occupied the homestead, while Elias Freeman and his family built another beautiful home c. 1870–1874 on the opposite side of Freeman Road several hundred feet south of the homestead. A son of Amos Freeman separated a large portion from the rear of the original house and moved it across Freeman Road, probably before 1897. In the early 1920s, another section was separated to create the house immediately to the south. Two other homes on the street were created from farm buildings.

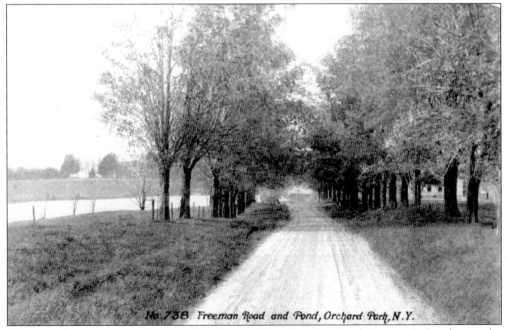

No. 738 Freeman Road and Pond, Orchard Park, N.Y.

This view looks north on Freeman Road toward East Quaker Road. Freeman's Pond is on the left, and the Quaker meetinghouse, on East Quaker Road, is behind the trees to the left.

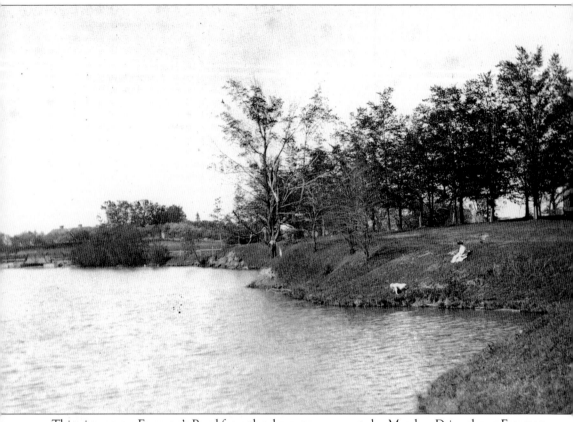

This view across Freeman's Pond from the shore near present-day Meadow Drive shows Freeman Road traversing left to right in the background. Elisha Freeman willed to his wife, Mary, who was widowed for 25 years, "all my household furniture . . . my two horse carriages and one horse buggy with the harness belonging to each, the sole use and management (as long as she remains my widow) of my dwelling house together with the three little buildings in the yard west of the house, the use of our half in common of the hog house, hen house, corn crib and wagon house, the use of two cows which as she may select from the herd every spring, the use of one horse, and if needed, occasionally the use of two horses. It is my will that she have one-third of the fruit that grows in the home orchard west of the road, gathered and stored ready for use, also wood prepared for use in wood shed, together with all and every necessary provision of food and raiment for her comfortable maintenance, together with the use of the yard for the purpose of passing to and from and around the buildings," and to his sons, "all of my real estate . . . to be divided equally between them . . . also . . . all of my personal property." It is admirable that Elisha and Mary Freeman had laid a healthy groundwork for a close business association between their sons and had confidence it would be successful in the years ahead. At the time of her death in 1890 at the age of 93, Mary Freeman was the oldest person in East Hamburg.

Seven

HARRY YATES

Orchard Park's preeminent patron was Harry Yates (1869–1956). A bold but cautious man, Yates became a captain of industry and finance and made important contributions to the building and economy of western New York, but balanced his success with public service and generosity to his community, charities, and worthy individuals. Coming to Buffalo in 1892, he became involved in enterprises that were essential to the growing late-19th-century city, such as ice, coal, iron furnaces, steel foundries, and railroads. He served on many boards, including the Manufacturers and Traders Trust Company, and was chairman of the Peace Bridge Authority. He owned the Hotel Lafayette and had an interest in New York's Commodore Hotel. In 1910, a Great Lakes freighter was named for him. As a boy, he spent summers on a farm where he nurtured a love of the land and animals and a lively enjoyment in nature—traits that took root in his character.

The cobblestone streets of Buffalo caused Harry Yates's coal wagon horses to develop sore feet. He sought a place to give them respite and found it in Orchard Park, where he bought his first farm. He soon bought a second farm for his manager. Although he was a fine horseman, and horses were always of keen personal interest to him, his business interest turned to dairy stock. More farms were bought for pasture and cultivation. He also purchased acres of woodland for water retention and conservation. By 1926, Yates Farms owned about 3,000 acres in Orchard Park: from Green Lake to Transit Road and from south of Jewett-Holmwood Road to north of East Quaker Road and beyond.

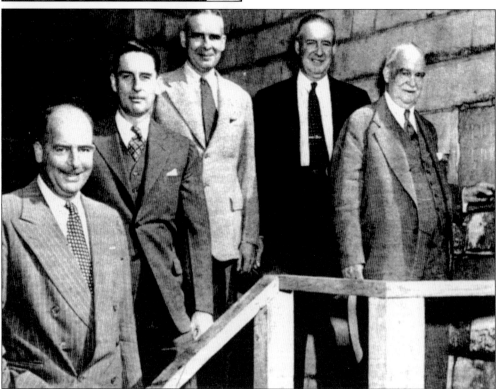

Harry and Mary "Mamie" (Duffy) Yates had four sons and three daughters. The sons, pictured in 1952 with their father (right), are, from left to right, Robert L., Harry D., Richard G., and Walter A. Yates. The Yates daughters were Theresa (the wife of Mr. More and, later, of Harvey Sherahan), Virginia (the wife of Henry Erb), and Elizabeth (the wife of William MacGreal).

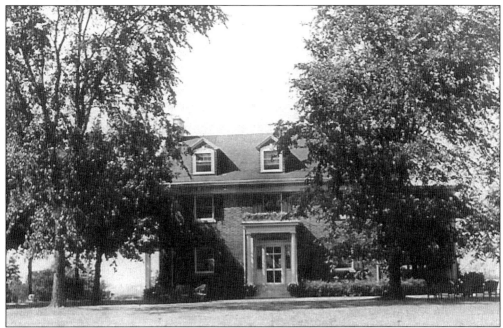

Although the family lived on Delaware Avenue in Buffalo, Harry Yates was captivated by rural interests. In 1906, he built his Hillhurst country home on East Quaker Road at the corner of Transit Road, where the family enjoyed holidays in the ambiance of the country with their Scottish terriers, saddle horses, and wild birds. Soon, it became their primary residence. In everything he did, Yates combined the astuteness of a man of business with the sound sense of a man of the soil. Farmer or financier, he was as pleased to be called one as the other. Frontal and aerial photographs show the residence as it was in his time.

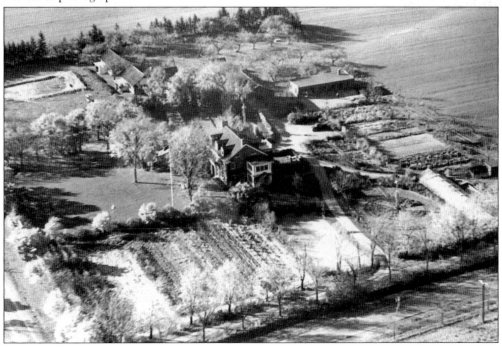

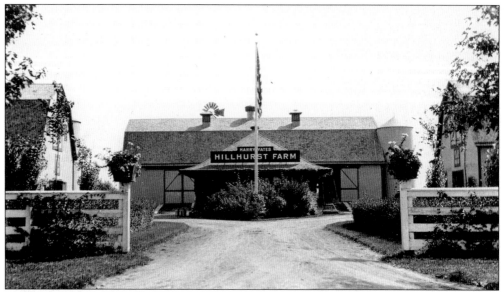

The main entrance to the primary buildings of Hillhurst Farms, on the south side of East Quaker Road, was 2.5 miles east of Orchard Park's Four Corners. Yates Farms owned many other barns and houses scattered about the community, but this was the base of the dairy enterprise. Below is an aerial view. The barn shown in the lower left still stands.

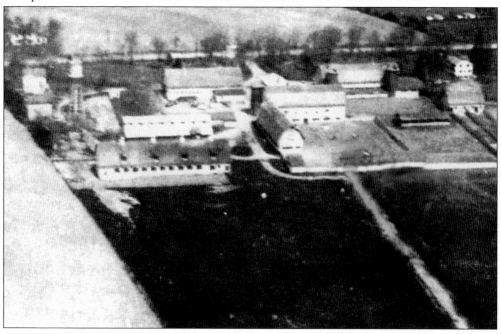

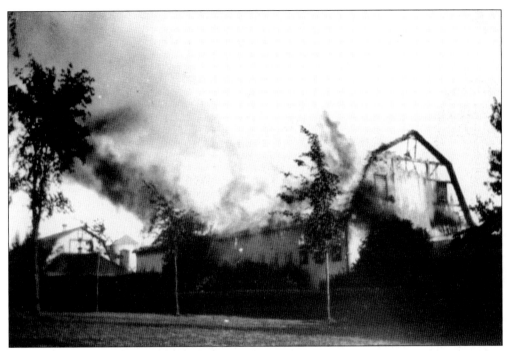

Hillhurst Farm lost a barn to fire in 1914.

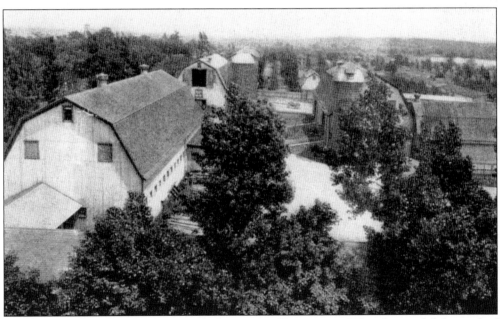

This July 9, 1925, photograph shows the barns of Hillhurst Farm. When horses did the work of the farm, it was a constant game for Harry Yates to search for perfectly matched teams of strawberry roans. Loving animals as he did, Yates took great pride in what he owned, and no horse or cow who had served the farm ever found its last day bewildering. There were pastures for the old stock, and at the end, a deep resting place was located in the Pine Woods. Service of any kind was always repaid with respect.

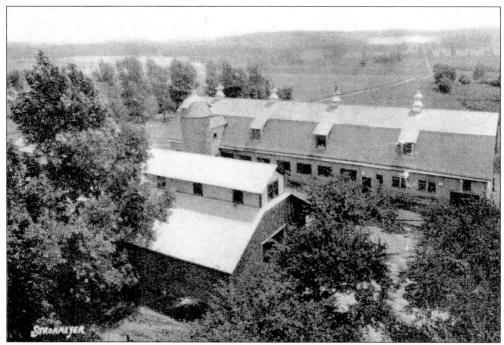

The breeding of fine dairy stock became Harry Yates's major interest. This was the test barn, photographed on July 9, 1925. The Holstein-Friesian purebred herd was established in 1911, and in 1926, numbered 175 head. Records made by this herd were known throughout the country and were a source of pride to Yates. This large barn still stands.

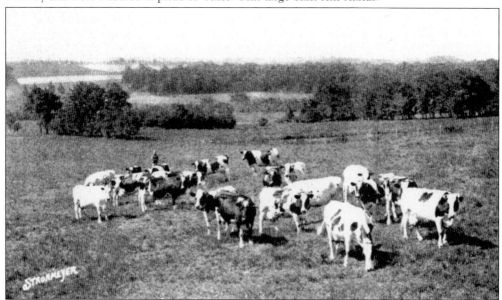

Photographed on July 9, 1925, these cows are in the test pasture. The milk and cream products were supplied to the Hotel Lafayette in Buffalo and sold on the open market. In the herd were 28 cows and heifers with semiofficial yearly records averaging over 1,000 pounds of butter, and there were nine cows with official weekly records of more than 30 pounds of butter. Never fewer than four bulls were in service.

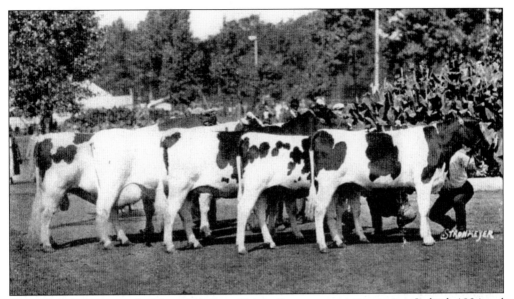

Harry Yates's entries in the New York State Fair in Syracuse were impressive. In both 1924 and 1925, his representative "Breeders Herd" and "Group of Four Cows, Three-Years-Old and Over" took first place. F.M. Nichols was Yates's herd manager. It is probable that his animals won more awards than we are aware of today.

"The Barn with the Lobby Look," now known as Quakerfield Stables, on Freeman Road, was part of the Nathaniel Swift farm in the mid-1800s and was acquired by Harry Yates in the early 1900s as he expanded his landholdings. Here, Yates installed a railroad siding known as the Yates Stop to ship cattle. Aberdeen Angus beef cattle, raised to supply Yates's hotel interests, once grazed these pastures. This is the interior after it was converted to a riding stable by Noel F. Sayers, proprietor. An entrance to a small apartment is visible at the end of the aisle. Yates also owned most nearby properties, including the former Ransom Jones farm on Jewett-Holmwood Road, which he named Edgewood Farm and where he raised beef cattle. Its Greek Revival house and large barns still stand.

In 1927, Harry Yates made a gift of five acres, located on the south shore of Green Lake, to the Girl Scouts of America. He is pictured (far right) on the day of dedication of that camp. He also gave the land for St. John's Lutheran Church and school, the Nativity of Our Lord Catholic Church and its cemetery, and the land on which the library was later constructed.

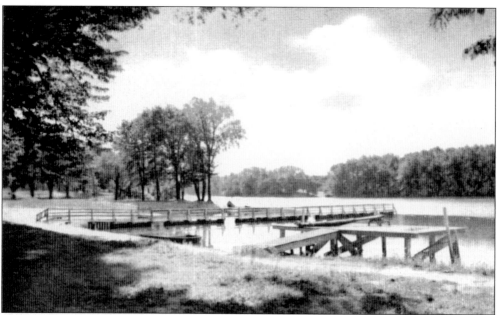

This c. 1948 photograph shows the Green Lake beach at the town park. Green Lake and the park were gifts to the town from Harry Yates. The Girl Scout camp is across the lake to the right.

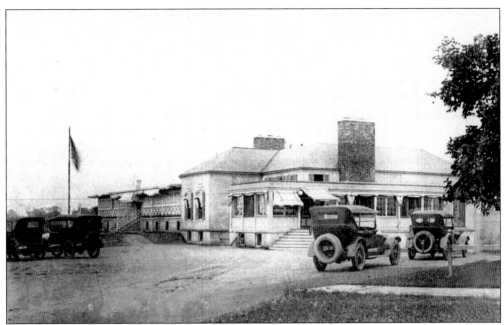

An avid golfer, Harry Yates coaxed the Park Country Club to build a satellite club in Orchard Park on 107 acres, which he owned, pointing out the ambiance of the community, convenience of the train station, interurban trolley, and good roads. Yate's attractive sale price of $19,500 was accepted, and a clubhouse and course were built. Play began in August 1917. Pictured c. 1920 are the front of clubhouse and a view from the north side. In 1946, a group of local residents, with Yates among the directors, formed the membership corporation of Orchard Park Country Club and purchased the clubhouse and present grounds from the Park Country Club for $75,000.

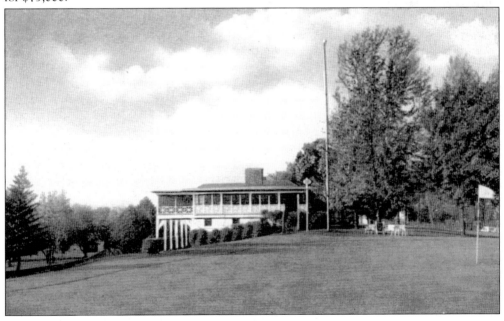

Harry Yates donated land for the construction of the railroad station and prevailed upon his father, the president of the Buffalo, Rochester & Pittsburgh Railway, to build the generous and exceptionally attractive station that Orchard Park enjoys today. He wanted the travelers arriving here to experience open space, fresh air, luxury, elegance, and leisure and patterned the station after the H.H. Richardson plan that had impressed him in Auburndale, Massachusetts. He dammed a portion of Smokes Creek, formed a lake basin, built an icehouse near the dam, and thus developed Green Lake as a source for ice to pack meat and produce from his farms for shipment to market via railway. Ice was also a commodity in itself. He had a siding built near the railway station for loading and unloading. Ultimately, electric refrigeration eliminated the need for this arrangement, and he deeded the lake and surrounding park to Orchard Park.

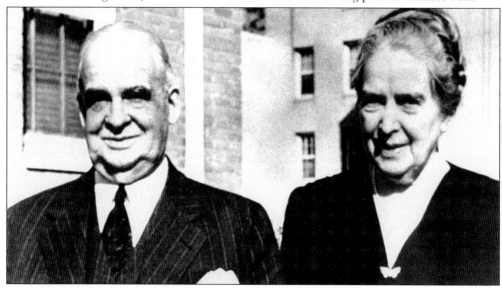

Motivated by the concept of helping a man to help himself, Harry and Mamie Yates were always ready to help deserving individuals. They took many philanthropic actions for which they chose to remain anonymous. They would often assist a boy or girl needing help financing a college education, a young man wanting to start a sound business venture, or a young couple longing to buy a home. In 1951, Orchard Park granted Yates its First Citizen award. He was given a plaque engraved with Cicero's words: "In nothing do men more nearly resemble the gods than in doing good for their fellow men." In their 64 years of married life, Harry and Mamie Yates's benefactions reached far and wide and were a great source of satisfaction to them. Orchard Park was a small crossroads village at the turn of the century, but Harry Yates was a visionary.

112

Eight
SOME CITIZENS WHO
SHAPED THE COMMUNITY

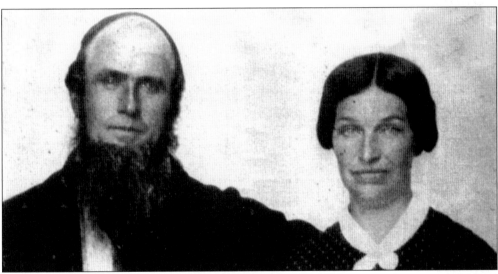

Gershom Jessup Knapp was born in 1819 in Connecticut and came to what is now Orchard Park c. 1840, with his parents, Enos Knapp Jr. and Elizabeth (Lockwood) Knapp, and other members of the Knapp and Lockwood families. In 1841, he married Polly B. Gwin and settled on Scherff Road, where he farmed and raised a family of seven sons and five daughters. He was a founding member of two churches in the community. In May 1853, he was among the original reorganizing members of the First Free Congregational Church of East Hamburg (for two prior years it had been the First Congregational Church, and is today's Orchard Park Presbyterian Church). In September 1853, he was an organizing trustee of the First Methodist Episcopal Church of East Hamburg, which was located on the south side of the present Chestnut Ridge Road Cemetery.

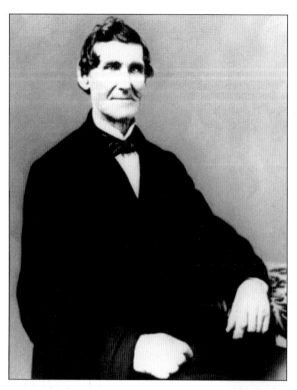

Harry Abbott (1796–1880), the son of pioneers Seth and Sophia (Starkweather) Abbott, married, in 1819, Quaker Margaret Potter (1800–1880), the daughter of pioneer Nathaniel Potter and his first wife, Ruth (Palmer) Potter. Margaret Potter was disowned by the Quakers for "keeping company and marrying one not a member of our Society," but she later apologized and was reunited with the meeting in 1827. Harry Abbott opened the first country store in Abbott's Corners (now Armor), operated a hotel with his brothers at that location, and served as the first postmaster of Hamburg in 1822. The family removed to Jewett-Holmwood Road c. 1835 to land Harry Abbott had inherited from his father.

Margaret Potter Abbott was a Quaker who is said to have been of "indomitable spirit" and "an influential and impassioned speaker in Friends' meetings." The prose of her surviving letters, usually using the Quaker "thee" and "thou," is insightfully poetic. She once wrote, "you are often the companions of my heart," and frequently expressed her concern of the health of others, such as when she penned the words, "if I could be there and give thee a fever powder and a light lobelie emetic." Her house burned when she was a widow of 84 years of age. This event inspired the line, "all that is of earth is uncertain and we have only to partake of the cup which is prepared for us," and caused her to contemplate her age, "what little time I am to remain in this tabernacle of clay, Providence permitting." The mother of two sons and four daughters, she died one month before her 89th birthday.

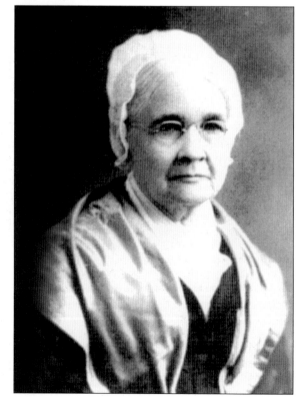

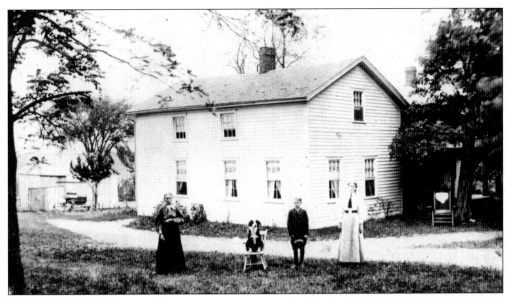

Harry and Margaret Abbott farmed and continued to raise their family in this house on the north side of Jewett-Holmwood Road, just west of the present intersection of Valley View Drive, having left Abbott's Corners. In the next generation, their son Marcus Abbott continued to farm here and raised his family of four sons and two girls in the same house. This c. 1895 photograph shows Marcus Abbott's wife, Frances (Bullis) Abbott; the family dog, Shep; son Bordon "B.J.;" and daughter Mary Grace, who later married John Sargent, builder of many homes in East Aurora. Harry Yates purchased the farm in 1905, and the house was razed. Note the surrey with the fringe on top parked near the barn.

Mary Ruth Potter (1861–1933) was a daughter of Cephas Leland and Susan (Wasson) Potter. She attended the East Hamburg Friends Institute and Old Central High School in Buffalo. She started a teaching career in East Hamburg schools when she was about 16 years old at a time when, she said, "They were not so fussy about a license and a certificate as they are now, and no signed contract was required by the board of trustees." She taught in schoolhouses at Deuel's Corners, Newton district, on Jones Road. In 1887, she became a member of the faculty of the Orchard Park Union School at a salary of $7 per week. Then, the high school consisted of two rooms on the second floor of the Lincoln School, newly built in 1885. She taught physiology, history, and mathematics. Her career in Orchard Park schools spanned almost 50 years. She was one of the district's best remembered and beloved teachers.

Dr. Willard Burton Jolls (c. 1871–1963) graduated from the University of Buffalo Medical School in 1895 and, within a couple of months, became a partner of Dr. Howard L. Hunt (1863–1928) in East Hamburg. In horse and buggy, the two doctors braved mud and snow, making $2 house calls around the countryside. Or perhaps they were paid in eggs, meat, or produce from the farm. Jolls was also an amateur photographer, and many of his pictures have survived.

Ida Markam married Dr. Willard Jolls on August 14, 1895, and settled in Orchard Park. She was a talented musician and was organist at the Orchard Park Presbyterian Church.

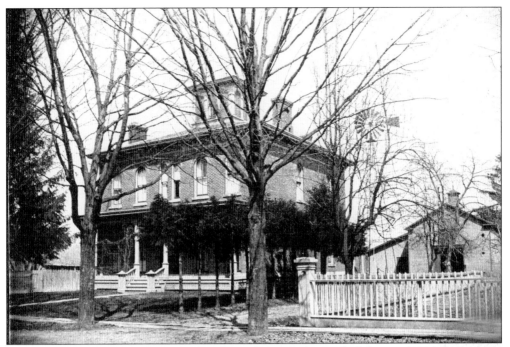

Built in 1869–1870 by prominent local merchant Ambrose C. Johnson (1824–1894), this classic Italianate home on South Buffalo Road was rented and then purchased by Dr. Willard B. Jolls in 1902. First using the living room of the house for his office, Jolls later added a medical suite to the rear of the building. This April 1900 photograph was probably taken by Jolls.

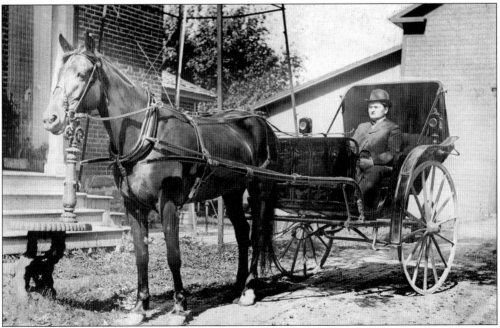

Dr. Willard B. Jolls kept his horse and buggy in the barn at the rear of his house, which is shown here *c.* 1908. It is said that he delivered some 1,200 babies in his years of practice. He retired at age 89.

Dr. Elisha Fitch Smith (1792–1867) was educated in the common schools in Cayuga County. He studied medicine and became a physician, and he moved to the Orchard Park area c. 1817 on horseback with a physician's bag and $2.50 in his pocket. He was to become the pioneer physician in this community. Smith built a cabin near what are now California and Duerr Roads and returned east to fetch his bride, Mary (Hussey) Smith (1791–1819). Unfortunately, she was not up to living in the harsh wilderness and she died after two years, leaving a daughter. Smith then married Elizabeth Howland (?–1876), and together, they had 11 children. He was a charter member of the Erie County Medical Society and also farmed. In 1831, he gave up the strenuous life of a country physician and became a full-time farmer. He served as supervisor of the town of Hamburg for 17 years and was elected to the state legislature in 1836 for two terms.

This strong countenance is that of 81-year-old Peter Arnold Kester (1805–1897). Kester came to the area in 1818 from New Jersey with his Quaker parents, Samuel B. Kester and Mary (Willson) Kester. He married his second cousin, once removed, Hannah Kester (1811–1833). Although they were both Quaker, they were both disowned by the local Quaker meeting for having been married by a local magistrate instead of in the Quaker tradition. Hannah Kester died after just a couple of married years, leaving no children. A farmer, Peter Kester then lived with his mother until she died at an advanced age in Orchard Park. He died at the home of Herbert A. Strong in Buffalo and was buried from the Friends' meetinghouse in Orchard Park.

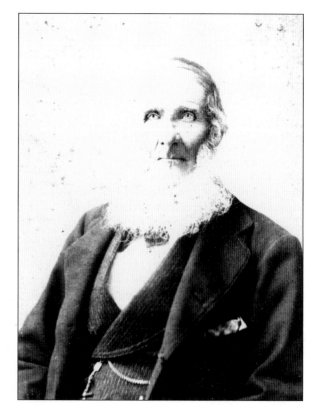

118

Nine

FIRE, POLICE, AND POSTAL SERVICES AND MUNICIPAL BUILDINGS

There was once a firehouse topped with a bell tower on West Quaker Road. It was located east of Veteran's Park on the site of the former municipal building. The volunteer fire company had first been organized in 1880, when they used hand-drawn carts, log ladders, and 12-quart buckets to fight fires. Many buildings were lost. The fire company incorporated in 1888, and in 1894, purchased this lot and subsequently built the firehouse. The words "Firemen's Hall" were inscribed in the transom over the front door. In case of fire, the bell would ring the alarm, and the volunteers would come from near and far. Their first motorized vehicle, a Stewart engine, was purchased in 1916.

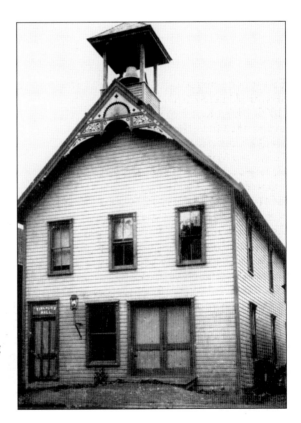

Alas, one cold day during Christmas week of 1918, the firehouse burned. The building was destroyed, and the fire also claimed Lemuel Cook's funeral home as well as a blacksmith and wagon-repair business. Heavily damaged was the first W.G. Arthur hardware store. The firehouse is fully engulfed in this photograph.

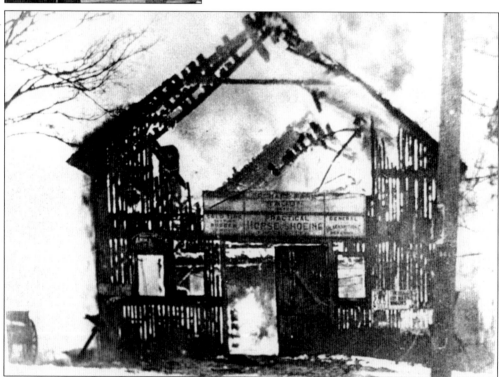

Shown is the burning blacksmith and wagon-repair shop during the 1918 fire. The sign over the door reads "Orchard Park Wagon, Practical Horse Shoeing."

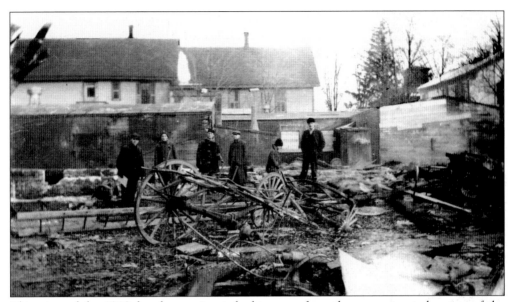

This view of the 1918 fire devastation is looking east from the approximate location of the burned firehouse. The still-standing Frame 'n Save building is in the background. The cupola of the Johnson-Jolls house is in the right distance.

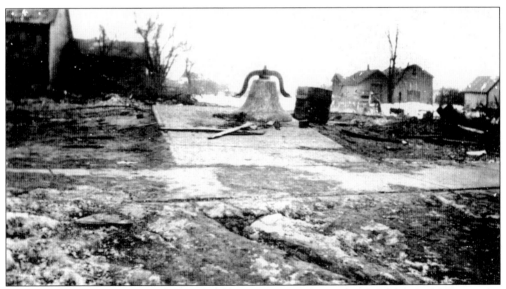

On the morning after the 1918 fire, there was nothing left but the fire bell. It had fallen to the concrete floor of the building and had suffered a large chip in the process. The bell was subsequently enshrined in a memorial in front of the current Orchard Park firehouse.

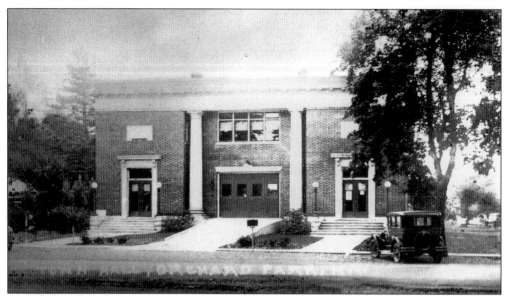

In 1925, a new municipal building was constructed on the enlarged site of the old firehouse. It housed the Orchard Park Village Hall (left) and the East Hamburg Town Hall (right), with the firehouse in the center. The upstairs was a community hall used for dances and special events. There also was a community library room.

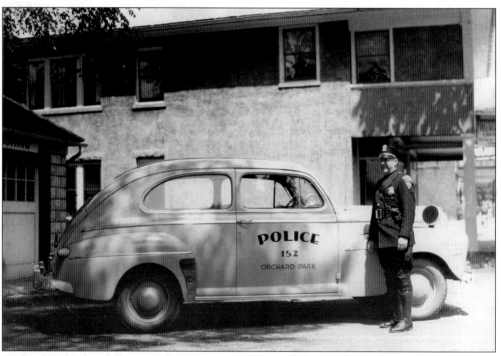

Orchard Park's first full-time policeman was William A. Martin. Prior to Martin's appointment in 1927, the state police maintained headquarters in the village. When the state police moved elsewhere, the community decided to begin its own force. Martin was the only officer until 1929, when William Haag was appointed as a second officer.

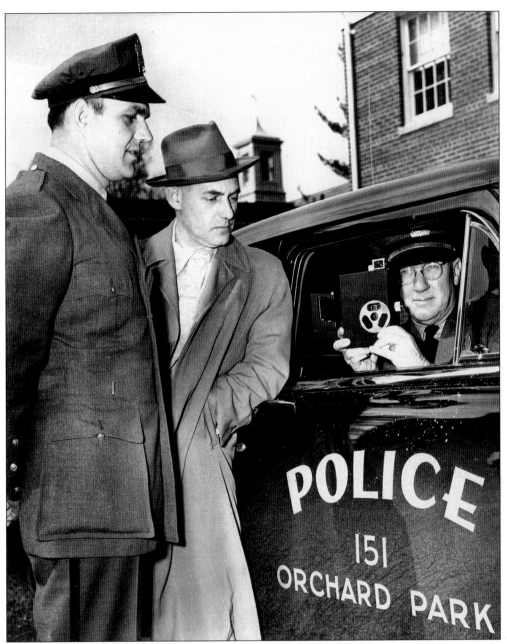

In 1927, William Martin was paid $35 per week and was given a remodeled closet in the firehouse as an office, a motorcycle, and $78 to buy equipment and a uniform. After 42 years of service, he retired in 1967, having watched the department grow to 17 officers. An accomplished amateur photographer, Martin is shown demonstrating a camera to officer Stanley Brzozowski and George Wakeman.

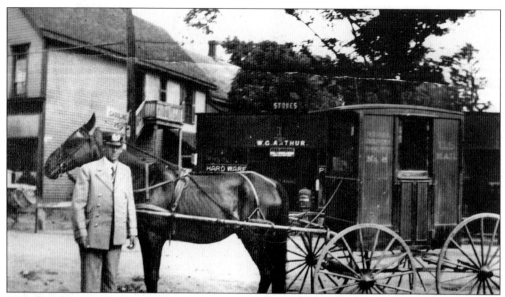

The post office set up the rural free delivery system (RFD) in what is now Orchard Park c. 1901. Prior to this, mail had to be picked up at a central location. This picture shows Albert Ellis with his horse and mail buggy c. 1915. In the background is the W.G. Arthur store.

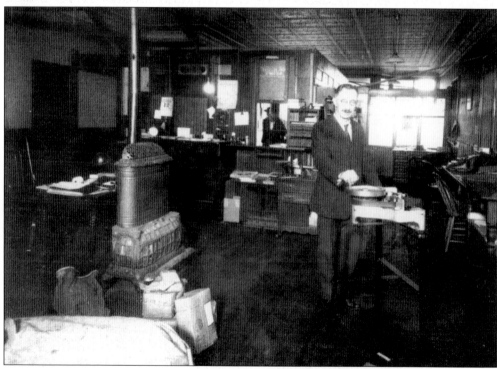

Postmaster Charles Brown and Jim Willis (at the window) are pictured c. 1923 in the store at the Four Corners (also shown when A.K. Hoag was proprietor on page 17). Bessie Willis was proprietor of the store c. 1923–1936, and Jim Willis, her husband, transported mail from the train station to the post office every day.

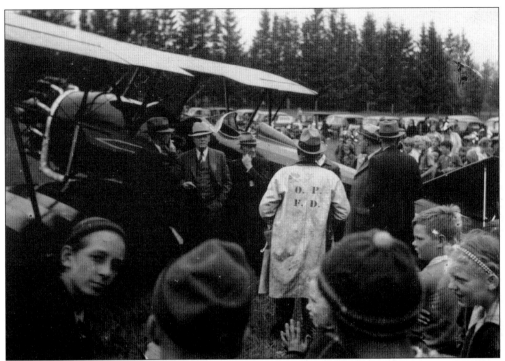

To celebrate National Air-Mail Week, on May 19, 1936, Orchard Park's mail was bagged at Arthur's post office location, driven by Dr. Willard B. Jolls with Postmaster Bret Hammersmith in his carriage to Yates Field (now Yates Park), where it was placed in this plane and flown out. This event was witnessed by hundreds of people. The Orchard Park Airport was opened in January 1946 near the southeast corner of Routes 20 and 240 but was never used for airmail.

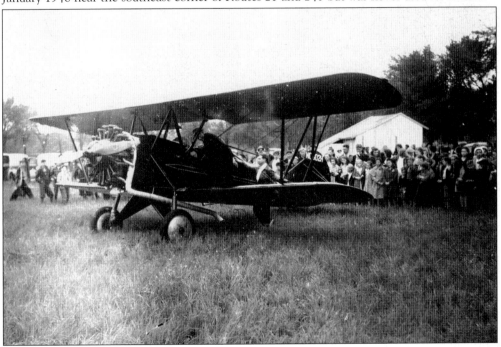

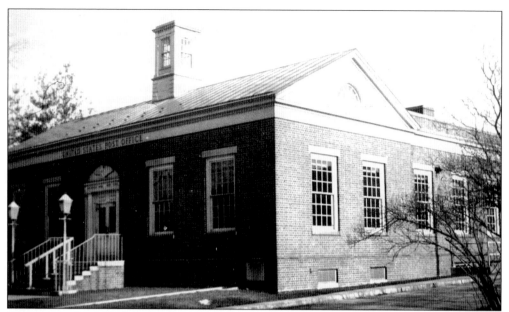

Built on the South Buffalo Road site of the former Clifford Hawkins house, a new Orchard Park post office was dedicated in 1941. It served the community until 1991, when a another post office was constructed. This building then became part of the municipal center.

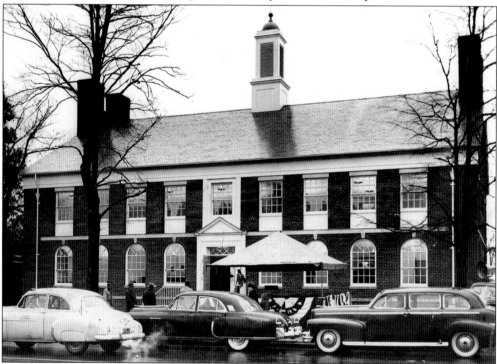

A speaker's stand was set up in front of the new municipal building for its dedication in November 1949. The building was constructed on a plot of land donated by Dr. Willard Jolls and located immediately south of his house. Gov. Thomas E. Dewey was the principal speaker at the dedication.

Ten
CHESTNUT RIDGE PARK

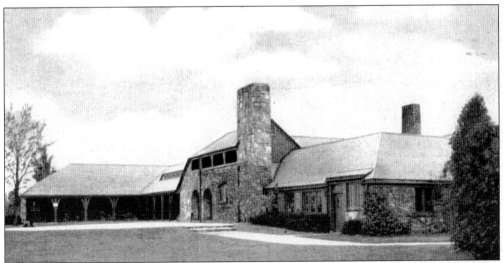

A pictorial history of Orchard Park would not be complete without mention of the community's greatest recreational asset, Chestnut Ridge County Park. Erie County's first park, it was founded in 1925 on 350 acres of land. Today, it contains over 1,200 acres. The central lodge (shown) is situated on the crest of a hill and offers a spectacular view of Buffalo and Lake Erie. There are 12 miles of roadway in the park, and native wildlife abounds.

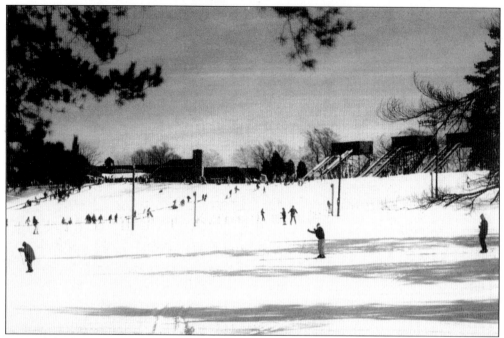

Most of the local children learn to ski and use a rope tow at Chestnut Ridge. The roofline of the lodge is visible on the left, and three toboggan chutes are seen on the right in this c. 1940 photograph. On the far left is a sledding hill. Also in the park are several tennis courts, 7,500 picnic tables, fireplaces, shelters, and a few cabins.

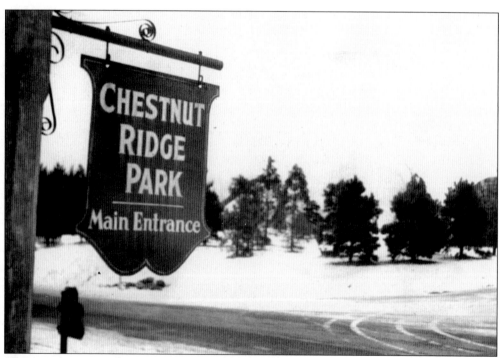

Shown is the sign at the main entrance of the park c. 1948.